Catalogue of The Newark Museum

TIBETAN COLLECTION

Volume I: Introduction

Valrae Reynolds
Amy Heller

The Newark Museum
Newark, New Jersey
1983

This publication has been supported by a grant
from the National Endowment for the Arts.
Research was funded in part by The Andrew W.
Mellon Foundation. Their generous sponsorship
is gratefully acknowledged.

Cover

The Potala, built in its present form
primarily between 1645 and 1695, view
from the north, Lhasa. Photo: Alix
Hoch, 1981

Designed by Frank Pietrucha/Graphic Design
Drawings and map by Bruce Pritchard
Type set by Newark Trade Typographers, New Jersey
Printing by Barton Press, New Jersey

Library of Congress Cataloging in Publication Data

Newark Museum.
 Catalogue of the Newark Museum Tibetan collection.
 Rev. ed. of: Catalogue of the Tibetan collection and other Lamaist
articles in the Newark Museum. 1st ed. 1950–71.
 Bibliography: v. 1, p.
 Contents: v. 1. Introduction.
 1. Art, Tibetan — Catalogs. 2. Art, Buddhist — Tibet — Catalogs.
3. Art — New Jersey — Newark — Catalogs. 4. Tibet — Civilization
— Catalogs. 5. Newark Museum — Catalogs. I. Reynolds, Valrae. II.
Heller, Amy, 1951–00. III. Title.
N7346.T5N48 1983 709′.51′5074014932 83-17293
ISBN 0-932828-12-4

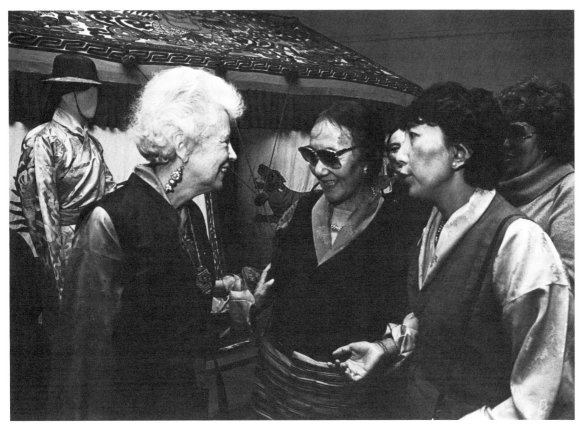

This volume is dedicated to the
memory of Eleanor Olson.

Frontispiece

Eleanor Olson, Dorje Yuthok and
Thupchu Yuthok at the opening
reception of *Tibet, A Lost World*, the
Newark Museum, March, 1981.

FOREWORD

The Newark Museum's Tibetan collection is regarded as one of the foremost holdings of such material in the world. Political events of the last twenty-two years have caused the disruption of traditional Tibetan culture, making the Museum's collection even more valuable as a record of a civilization now vastly altered.

The unique nature of the collection is that this record is so complete. It includes objects of everyday life as well as painting, sculpture and ritual material. The Museum is proud that it has not only amassed this collection but that it also has consistently supported related research and publication.

I have been personally gratified that during my tenure as director the Museum has had the great honor of two visits by His Holiness, the 14th Dalai Lama, in 1979 and 1981. The Tibetan collection also received the recognition of a national tour of three hundred selected objects, *Tibet, A Lost World*, sponsored by the American Federation of Arts in 1978-80. Prior to that, in 1976-77, many of the collection's finest pieces travelled to Paris and Munich as part of a major international loan show.

The first edition of the five-volume *Catalogue of The Newark Museum Tibetan Collection*, produced between 1950 and 1971, was the life work of then curator Eleanor Olson, to whom we owe a great debt for her pioneering work and devotion to Tibetan scholarship. The publication of the revised edition of volume I is evidence of the Museum's continued commitment to this great assembly of art and ethnography.

Valrae Reynolds, Curator of the Oriental Collections, has supervised all aspects of this volume and written much of the text (see Notes, page 7). I applaud her dedication to excellence and care in bringing this new edition to press. I also would like to recognize the valuable contributions of scholars Amy Heller and Lobsang Lhalungpa.

The Museum is indebted to the contributors to the Eleanor Olson Memorial Fund, to the Andrew W. Mellon Foundation which provided funds for research, and to the National Endowment for the Arts for the generous contribution which has enabled this new edition to be published.

Samuel C. Miller
Director

CONTENTS

	Page
Acknowledgements	6
Explanatory Notes	7
Map	8 & 9
I. Geography	11
II. History	15
III. Religion	29
IV. Society	43
V. Architecture	48
VI. The Newark Museum Collection	54
VII. Symbols	67
Selected Bibliography	79
Index of Illustrations	83

EDITOR'S ACKNOWLEDGEMENTS

Eleanor Olson's pioneering work on Tibetan art and ethnography resulted in the five-volume *Catalogue of The Newark Museum Collection*. Volumes I and III have been out of print for some time and all five volumes require substantial updating to include additions to the collection made since each was completed (I–1950, II–1950, III–1971, IV–1961, V–1971), and to incorporate changes in the political and cultural status of Tibet. Great advances have been made, as well, in the body of scholarly knowledge about all aspects of Tibet. When the decision was made to undertake the task of publishing a completely revised edition, it was judged important to take advantage of the presence of distinguished scholars working in the Tibetan field. I have been very fortunate to have been able to work with Amy Heller, a doctoral candidate at the Ecole Pratique des Hautes Etudes, Paris, on volume I. Mrs. Heller's scholarly expertise draws on her work at European universities and on her close relationship to Tibetan scholars working in Europe and America. I have also been privileged to have the advice of Lobsang Lhalungpa, a noted scholar, whose knowledge of traditional Tibetan civilization is perhaps unique among Tibetans living in the United States.

Others who have generously given their assistance in the publication are Tenzin Tethong and the staff of the Office of Tibet, New York City, Nima Dorje, Janet Gyatso, Matthew Kapstein, Elliot Sperling and G. Evelyn Hutchinson.

At the Newark Museum, Margaret Di Salvi and Helen Olsson have given valuable assistance in bibliographic and photographic research; Ruth Barnet has cheerfully typed many manuscript drafts and Bruce Pritchard has supplied fine maps and drawings. Mary Sue Sweeney has given invaluable help in the final editing and provided advice and encouragement at every stage in the development of this project. Director Samuel C. Miller has given his enthusiastic support to the research and publication from its first conception and ensured its successful completion.

Valrae Reynolds
Curator of Oriental Collections

EXPLANATORY NOTES

The chapters on Geography, History and Religion were written by Amy Heller; those on Society, Architecture, the formation of the Newark Museum's collection, and Symbols by Valrae Reynolds. Lobsang Lhalungpa has assisted on chapters I, II, III and VII.

To give a simplified and coherent rendering of Tibetan (T.), Chinese (C.) and Sanskrit (S.) words, phonetic spelling has been used whenever possible. When Tibetan words first appear, their correct transcription (Wylie system) is given in parentheses. The modern Chinese system (*Pin Yin*) has been used for Chinese spelling except where historical context makes it incongruous. Foreign words which have not become part of standard English usage are defined when they first appear.

The University of Chicago Press style has been used for footnotes which occur on the text page to which they refer.

Bibliographies are listed by chapter, at the end of the catalogue. Asterisks (*) appear next to entries which are recommended as standard texts on the subject.

An index of illustrations with explanatory notes about the Newark Museum's photographic archive is given on page 83.

N.B. Those familiar with the original edition of volume I may miss, in this revised edition, the listing of Tibetan collections in the United States and Canada. Since this sort of listing is impossible to keep current, it has been eliminated. Readers are advised to consult *Tibetan Resources in North America*, published by the Asia Society of New York City and periodically updated.

• Khotan XINJIANG

 Kunlun Mountains

LADAKH Karakorum

• Leh Mountains CHANGTHANG

 Indus River

Dharm-
sala TOH T I B

• ⟂ NGARI
Sutlej GUGE • Gartok
 River • Tsaparang

 ▲ Mt. Kailasa
 ∞∞ Manasarowar Lake H i m a l a y a s

 N E P A L

• Delhi

 Kathmandu •

 Ganges River

 I N D I A

TIBET AND AREAS
OF INFLUENCE

▬▬ Political borders (prior to 1959)

▢ General area inhabited by
 Tibetans (20th century)

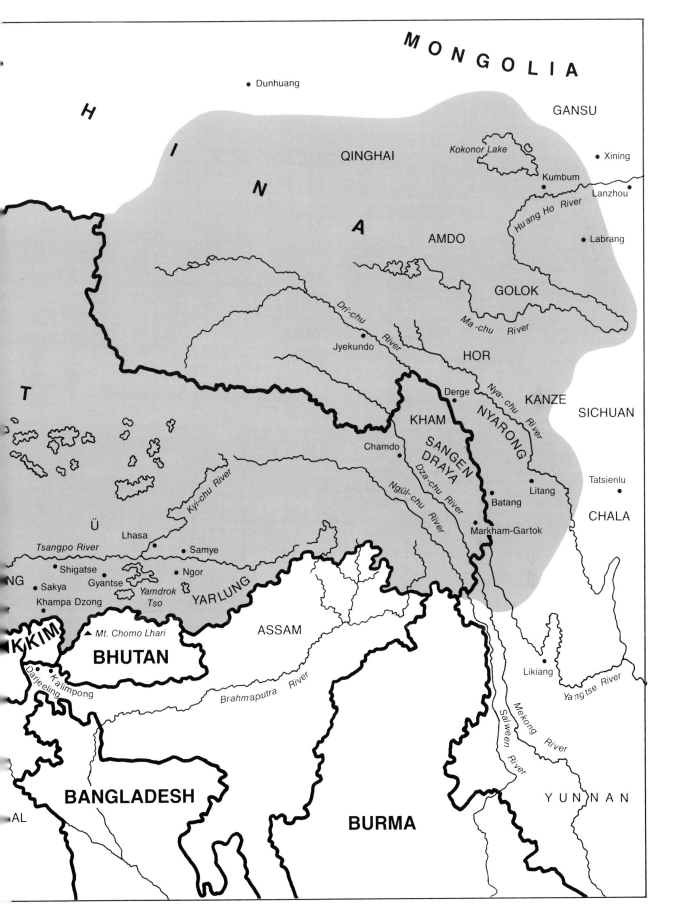

MONGOLIA

H

I

N

A

• Dunhuang

QINGHAI

GANSU

Kokonor Lake

• Xining

Kumbum

Lanzhou

Hu ang Ho River

AMDO

• Labrang

GOLOK

Dri-chu

River

Ma -chu

River

• Jyekundo

HOR

Nya-chu

River

KANZE

SICHUAN

• Derge

T

KHAM

NYARONG

• Chamdo

SANGEN
DRAYA

Dza-chu River

Tatsienlu

Kyi-chu River

Ngül-chu River

• Litang

CHALA

Ü

Lhasa

• Samye

• Batang

• Shigatse

• Ngor

Markham-Gartok

Tsangpo River

NG

• Sakya

Gyantse

*Yamdrok
Tso*

YARLUNG

▲ Mt. Chomo Lhari

ASSAM

Khampa Dzong

IKKIM

BHUTAN

Likiang

K alimpong

Darjeeling

Brahmaputra River

Ya ng tse River

Salween River

Mekong River

BANGLADESH

Y U N N A N

AL

BURMA

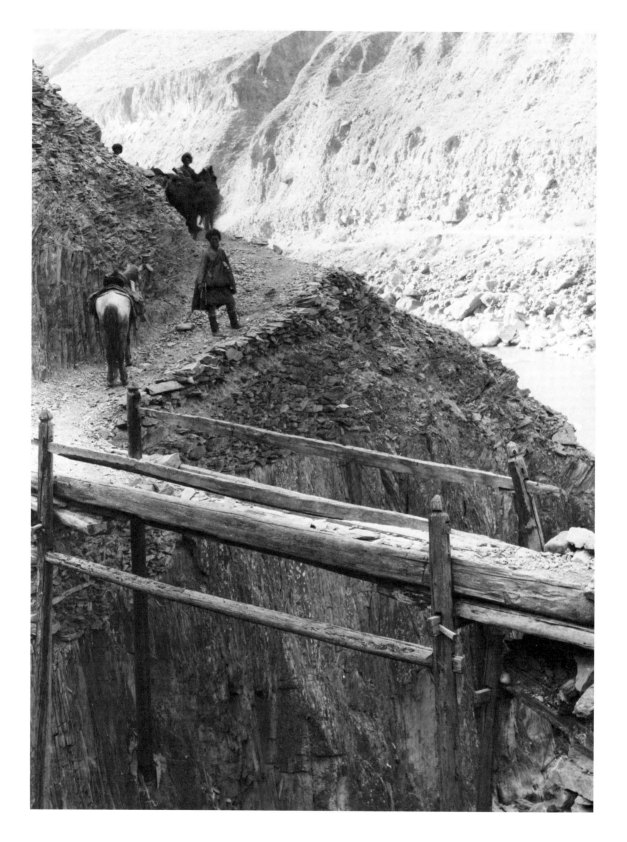

I. GEOGRAPHY

Situated in the heart of Asia at a mean altitude of 14,000 feet, Tibet, the "Land of Snows," is isolated by climate and terrain and yet irrevocably linked with its neighbors by ethnic, cultural and religious ties. Despite the existence of numerous dialects in the Tibetan spoken language, the written language which dates from the seventh century is used as a religious lingua franca from Ladakh and Nepal to western Sichuan, and from northern India to Inner Mongolia, as these areas are culturally influenced by Tibet and its particular form of Buddhism.

The political borders of Tibet have varied through the centuries. From the sixth to ninth centuries A.D., the Tibetan empire extended as far north as the ancient silk routes, as far west as the Oxus River, as far south as Nepal and northern India, and as far east as Chang-an, the capital of Tang China, which was long under seige by Tibetan warriors. In modern times, political Tibet (now known as the Tibetan Autonomous Region) has been formed of the regions of Ü (with Lhasa the capital as its center), Tsang, Toh, Changthang and western Kham. Portions of northern and eastern Tibet were incorporated into the Sinkiang, Kansu, Tsinghai and Sichuan provinces of China. Topographically, the borders may roughly be defined by the Himalayas to the south, by the Karakorum range to the west, and by the Kunlun range to the north, while to the east, the Gansu corridor and a Sino-Tibetan borderland may be defined by the area of the

FIGURE 1 (Left)

Trail along the Mekong River (Dzachu), Kham. Photo: Shelton, ca. 1910 (052-S)

FIGURE 2

Boundary marker with prayer stones and flags; Chinese writing: "West border of Lihua Ting" (l.), "East border of Sanpa Ting" (r.), Kham. Lihua (Litang) and Sanpa (Itun) were two areas east and south of Batang designated as Chinese administrative districts by Chao Er Feng in 1911. Photo: Shelton, ca. 1913 (D34-S)

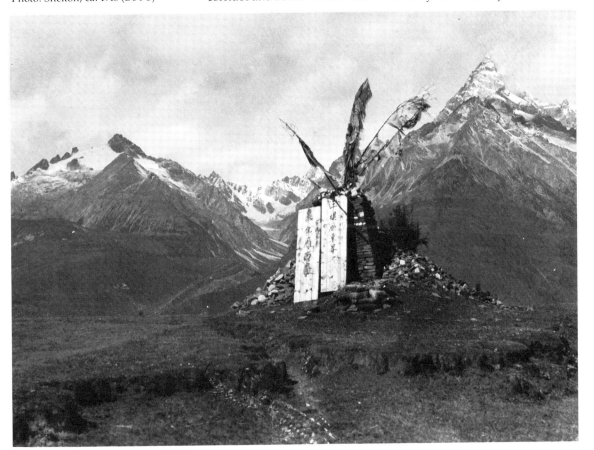

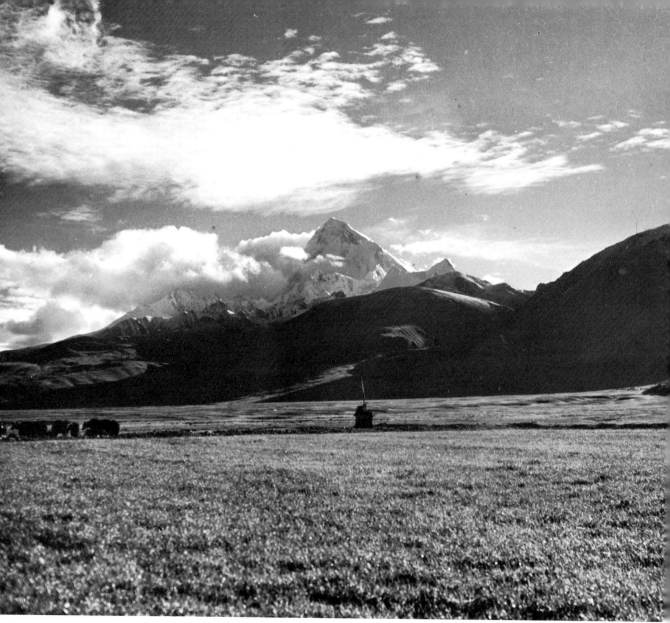

FIGURE 3

Mt. Chomo Lhari (23,930 feet) with
cultivated fields in foreground, Tsang.
Photo: Cutting, 1935 (Q36-C)

Yangtse watershed (T. Dri-chu and Nya-chu) and Huang Ho (T. Ma-chu)
Rivers.

For purposes of clarity, we may consider this vast space, approximately
seven times the size of France, in three horizontal bands: the fertile valley
of the Tsangpo River running parallel to the Himalayas; a band of high-
lands used for grazing and nomad herds, and in the far north a desert
area, the Changthang region. Tibet's latitude is on the same parallel as
Algeria. Despite great extremes of temperature in the 15,000-foot moun-
tain passes used by the caravan routes which have crisscrossed Tibet
since time immemorial, wheat, peas, rye, fruits and vegetables grow
easily in the warm valley of the Tsangpo. Barley, the principal staple, may
be grown almost everywhere but the Changthang, even at extreme
altitudes. In the east, densely wooded forests cover the hillsides while
rice is sown in some of the valleys. Vertiginous gorges of sheer rock
characterize certain areas of the Sino-Tibetan borderland. As the land is

traversed north, south, east and west by several smaller mountain ranges, each region has its own fields, hillside pastures or woodlands, and mountains, often with great variation due to exposure of sun or winds from one side of the mountain to the other.

The yak (*Bos grunniens*), a member of the cattle family which flourishes at high altitudes, is the indigenous animal of Tibet. The yak and a hybrid of yak and cattle (*T. dzo*) both provide hair, hides and dairy products and are also beasts of burden capable of carrying up to 160-pound loads. Sheep and goats which thrive well in high altitudes are also significant animals in Tibet's pastoral economy. Tibetan horses and musk, the product of the Tibetan musk deer, were once important trade commodities.

By virtue of the variations due to altitude and climate, there are two major axes of Tibetan livelihood, the nomad and the sedentary farmer, reflecting the dichotomy of mountain pastures and sown fields. Precipitation is scanty in the west, where the Himalayas block the monsoon, but increases steadily as one travels further east along the Tsangpo River. Irrigation has been known in the Tsangpo basin since prehistoric times. The eternal snows at the summits of the 25,000-foot mountains are legendary, but even if the mountains are omnipresent, it must be emphasized that the image of Tibet as a cold, wild, inhospitable country is false.

Three principal cities grew up along the caravan routes in the area of the

FIGURE 4

Prayer stones and flags marking the Kharo-la pass between the Tsangpo Valley and the Yamdrok Tso Valley, central Tibet (Ü).
Photo: V. Reynolds, 1981

Tsangpo River valley. South of the Tsangpo is Shigatse, the commercial city closest to the western caravan route arriving from Kashmir and the Indus valley. Gyantse is also south of the Tsangpo, but due north of Sikkim and on a trade route which led to the Ganges valley, conveying salt and musk to India. Lhasa, the capital, lies north of the Tsangpo on a tributary. Population estimates of ethnic Tibetans were 6 million prior to 1959. The current estimate of the population of the Tibetan autonomous region is 1.8 million, although conflicting figures exist of Tibet's population over the centuries. The International Commission of Jurists' 1960 report gives figures ranging from 10 to 15 million for the total ethnic Tibetan population.[1]

FIGURE 5

Lake Yamdrok Tso with snow-covered Himalaya range visible in the far distance (looking to the south), central Tibet (Ü). Photo: V. Reynolds, 1981

1. International Commission of Jurists, *Tibet and the Chinese People's Republic*, p. 290.

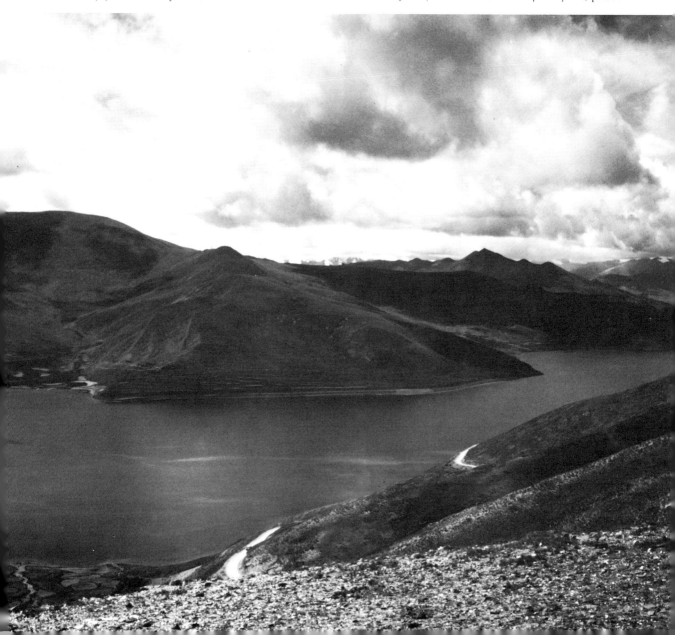

II. HISTORY

In the seventh century A.D. when historic records of Tibet began,[1] the valley of the Tsangpo River was the home of independent tribes and minor tribal confederations. According to legends which seem to have their basis in fact, these tribes, speaking varied dialects of the Tibetan language, were politically unified from the end of the sixth century through the late seventh century. The rulers of central Tibet, based in the Yarlung Valley situated southeast of the Tsangpo, had conquered one by one the Tibetan tribes and principalities of the entire Tsangpo and gradually extended their territory to include non-Tibetan confederations in the northern, western and northeastern parts of the plateau. For two centuries this new nation was a formidable military power known and respected throughout Asia. The Tibetans of central Tibet were clustered in semi-nomadic and farming communities, living in tents protected by fortified stone walls and watchtowers. Although divided into principalities, the entire population took an oath to the most powerful lord, the *tsenpo* (*btsan po*) of Yarlung.[2] He unified his territory by matrimonial alliances with rival tribes and foreign powers as he further expanded the domain by military conquests.

Tibet was commercially active, crisscrossed by trade routes.[3] Early seventh-century records document export of armor and weapons, horses and other animals, textiles, salt and the prized Tibetan musk. The Chinese Tang Annals record a spectacular gift received from Tibet in 641 A.D., a goose-shaped golden ewer seven feet high and capable of holding sixty litres of wine. In 648, a miniature golden city decorated with animals and men on horseback was presented as a gift.[4] As one author has written:

> To judge from the records of tribute and gifts from
> Tibet to T'ang which over and over again list large
> objects of gold, remarkable for their beauty and rarity
> and excellent workmanship, the Tibetan goldsmiths
> were the wonder of the medieval world.[5]

Control of the lucrative trade routes and the sacred role of the tsenpo to conquer provided the major impetus for military expansion. The first historic tsenpo, Songtsen Gampo (*Srong btsan sgam po*, reign 620–50 A.D.),

1. The historical sources for this period are meager but revealing. A cache of seventh- to tenth-century Tibetan manuscripts was discovered at Dunhuang in the early twentieth century; among these manuscripts are year by year Tibetan annals covering the reign of Songtsen Gampo. The Tibetan custom of inscriptions on stone pillars erected at the consecration of temples and signing of treaties and pacts dates from the eighth century. Buddhist theologians wrote detailed religious and political histories as of the twelfth century, compiled from much earlier material. The *terma* texts also provide historical information. For prehistoric Tibet, one must rely on legends and traditions written down at a later date, but which show the "invariability of the main sequence of the myths, legends and traditions" (Erik Haarh, *The Yarlung Dynasty*, p. IX).

2. Elliot Sperling, "A Captivity in Ninth Century Tibet," pp. 23, 29–30, explains that the Chinese term *tsan-p'u* (贊普) used to translate *tsenpo* is the equivalent of "emperor" rather than "king," which certainly better connotes the quality of a confederation of tribes under one leader in seventh- to ninth-century Tibet.

3. On Tibetan trade in general see Christopher Beckwith, "Tibet and the Early Medieval Florissance in Eurasia."

4. Paul Pelliot, *Histoire Ancienne du Tibet*, pp. 5,6,84, cites the Chinese documents *Kieou T'ang Chou* 196A and *Sin T'ang Chou* 216A for the ewer.
Edward H. Schafer, *The Golden Peaches of Samarkand*, p.254, cites Paul Demiéville, "Le Concile de Lhasa," *Journal Asiatigue*, 1975, for the golden city.

5. Schafer, *Golden Peaches*, p. 254.

conquered portions of the ancient silk route, bringing the Tibetans in contact with Central Asian and Chinese cultures. Songtsen made vassal states of Nepal, portions of northern India and Zhangzhung, a separate area formed of western Tibet and part of northern India. His successor occupied the oases of Khotan, Kucha, Karashahr and Kashgar from 665–92, and gained control of the Nan-chao kingdom (now the Yunnan region of China) as of 680. Songtsen established Lhasa as his capital, moving from the Yarlung Valley with his five wives: a Chinese princess, a Nepalese princess and three Tibetan noblewomen.

Tradition credits the two foreign wives with the introduction of Buddhism and for the construction of the first Buddhist temples in Lhasa.[6] It seems certain that Songtsen did not become exclusively a Buddhist, however, as numerous documents survive indicating his royal patronage of the indigenous organized religion, probably called *Tsug (gTsug)*, which deified the tsenpo and guaranteed his "divine right" to rule.[7] Nonetheless, the introduction of Buddhism was part of a multi-faceted interaction, economic, cultural and political, between the Tibetan royal government and the cultures of India, Nepal, Central Asia and China. Tsenpo Songtsen's minister, Thonmi, was sent as an envoy to India to adapt a script for the Tibetan language.[8] Songtsen's reign is also credited with the establishment of the first legal code.

During the reign of Songtsen Gampo's great-great-grandson, Trisong Detsen (*Khri srong lde btsan*, reign 755–ca. 797/98 A.D.), Tibet again extended its control along the silk route, occupying Dun Huang, the western gateway to China, from 787 to 866. In central Tibet, an inscribed stone pillar attests to the fact that this tsenpo founded the first monastery, Samye (*bSam yas*), midway between the Yarlung Valley and Lhasa, ca. 775. Traditionally it is recounted that Padmasambhava, a Buddhist master from Oddiyana (now believed to be the Swat Valley, Pakistan), came at Trisong Detsen's invitation to subdue the indigenous deities opposing this monastic center.[9] Chinese Buddhists of the Ch'an order and Indian sages of Mahayana and Vajrayana Buddhism came to Samye, influencing the tsenpo to issue an edict ordering his subjects to adopt Buddhism in ca. 790. The noble families formed ardent pro- or anti-Buddhist factions.

In the first half of the ninth century, three tsenpo in succession officially supported Buddhism, while still practicing the indigenous religion which ensured their theocracy. A major Sino-Tibetan treaty was signed in

6. Giuseppe Tucci, "The Wives of Srong btsan sgam po," pp. 123–8, doubts that the Nepalese wife ever existed as she is not mentioned in historical sources prior to the fourteenth century. Tradition, however, affirms this marriage, see Rolf A.Stein, *La Civilisation Tibétaine* (1981), p. 36.

7. See Religion chapter, pp. 31–32. The principal source for Tsug is Ariane Macdonald, "Une lecture des P.T. [Pelliot Tibétain] 1286, 1287, 1038, 1047, et 1290. Essai sur la formation et l'emploi des mythes politiques dans la religion royale de Sroṅ bcan sgam po." A very good summary is also to be found in Anne-Marie Blondeau, "Les Religions du Tibet."

8. Stein, (1981), p. 37, explains that it is highly unlikely that in the twenty years of Songtsen's reign, Thonmi codified the alphabet enabling Tibetan texts by ca. 644 to already be in Dunhuang far from Lhasa. Furthermore Thonmi does not appear in the lists of ministers in the Tibetan annals for the period. See Hugh E. Richardson, "Ministers of the Tibet Kingdom," *Tibet Journal*, vol. 2, no.1 (1977). Nils Simonsson, *Indo-Tibetische Studien*, Uppsala, 1957, thought Thonmi was perhaps late eighth to ninth centuries. Nonetheless, he is traditionally attributed as the creator of the Tibetan alphabet.

9. For a discussion of Padmasambhava's role in the first diffusion of Buddhism to Tibet see Tucci, *Religions of Tibet*, pp. 5–7.

822. This bilingual text between the two sovereign powers settled border disputes and established a pact of non-aggression. The tsenpo Ralpachen (*Ral pa can*, reign 815–38) followed his predecessor's policy of taxation of the noble families to support the monasteries, and added two Buddhist clerics to the group of royal ministers. The noble families' exclusive privileges were thus being eroded in favor of the clergy.

In 838 tsenpo Langdarma (*gLang dar ma*, reign 838–842) was enthroned and is said to have severely persecuted Buddhism.[10] His assassination four years later is attributed to a Buddhist monk. Langdarma's heirs fought for the throne and the empire fell into chaos. The Tibetans lost control of the oases along the silk route as of 866. Trade with the Arab Caliphate continued throughout these troubled times.[11] According to Arab and Persian sources, Tibet maintained control of the southern Pamirs and even the southeastern parts of Farghana well into the tenth century, but the Tibetan empire was lost. Branches of the royal lineage survived in Amdo and western Tibet, while central Tibet broke into small principalities under the rule of noble families.

This relatively short dynastic period of Tibetan history provides essential insights into the formation of the Tibetan state and the nature of Tibetan society and religion. Parallel situations recur throughout Tibetan history, when instead of rival clans, the claimants for power will be various orders of Buddhism supported first by the noble families and later by various foreign rulers aligned with certain of these families. The original social structure of Tibetan society was perpetuated in the clans and nobles, all of whom vied for the tsenpo's favors, expressed through distribution of land grants and annuities. The nobility was hereditary and each clan was associated with a particular geographic locale. If a noble or lord had no heir, the estate returned to the tsenpo. The members of the nobility were responsible for counseling the tsenpo and furnishing men, arms and horses for his military campaigns, in addition to providing daughters for the politically-based matrimonial alliances. Aside from the clergy, those who were not nobles were divided into subjects or serfs from conquered tribes. The subjects could be socially mobile, capable of entering the clergy or rising to the status of the nobility. The celibate clergy first relied on heredity to ensure succession, which initially passed from uncle to nephew. Later, reincarnation replaced heredity to establish succession. Already at the time of Songtsen Gampo, a non-Buddhist priestly class with several internal divisions existed. Later, as the Buddhist clergy became numerous, a tax-exempt status was accorded to both the monks living in the monasteries and to the adepts living in meditative retreat. The nobility was taxed to provide for the needs of the clergy and the upkeep of their establishments, a situation which continued through modern times. The major cohesive factor of the dynasty had been the tsenpo and the religion he embodied. As royal concessions to Buddhism were made, the politico-religious institution which guaranteed the tsenpo's theocracy and the stability of the empire disintegrated, only to be replaced by the establishment of the Buddhist ecclesiastical state which governed Tibet until 1959.

Because of the upheaval following the fall of the Yarlung dynasty, there was a hiatus of historical records of almost one century. When records

10. This is the traditional account, however Blondeau, "Les Religions du Tibet," p. 254, cites a Buddhist petition in favour of Langdarma among the Dunhuang manuscripts.

11. Beckwith, "Empire in the West," p. 35.

resume in the mid-tenth century, Buddhism was well established in Tibet and had become the underlying grid over which economic, political and social institutions would develop. Descendents of the tsenpo played a vital role in reviving Buddhism in Guge, a principality of western Tibet. Royal patronage allowed numerous religious pilgrims to travel to Buddhist Kashmir. Prominent among these was Rinchen Zangpo (*Rin chen bzang po*, 958–1055) who returned to Guge bringing Buddhist texts for study and translation, as well as artists to decorate newly-founded temples. Indian panditas or teachers such as Dipamkara Atisha (in Tibet 1042–1054) came to Tibet to proselytize and clarify Buddhist philosophy and ritual practices. In the eleventh century, many Tibetans travelled to India, Nepal and Kashmir as pilgrims, then returned to Tibet to spread their newly-acquired knowledge. In addition to making translations of Sanskrit and Chinese Buddhist texts, the Tibetan teachers began to write their own commentaries and texts on all aspects of Buddhist thought. A core of disciples surrounded each master, leading to the establishment of many diverse Buddhist religious orders and monasteries in Tibet. The Tibetan nobility and wealthy principalities patronized the various new religious movements.

It was not long before the monastic establishments vied with their very patrons for land ownership and commercial profits. Increasingly the monasteries played the role of financiers or creditors. Shifting alliances between the powerful lay patrons and the sectarian orders led some monks to adopt a political role in addition to their traditional one of religious guidance and spiritual instruction. When the Mongols threatened Tibet's northern borders in 1240, Sakya Pandita (*Sa skya pandita*, 1182–1251), a learned lama of the Sakya order, was invited to the Mongol camp of Godan Khan. Godan wanted a written form of the Mongolian language developed which the scholar started to prepare, while interceding as political negotiator to sway the Mongol invasion of Tibet. In 1249, Godan assigned political control over Ü and Tsang to the Sakya order. After the death of Godan and Sakya Pandita, another Mongol invasion of Tibet occurred, led by Kublai Khan. This Khan in turn became the patron of Sakya and again conferred rule of Ü and Tsang as well as the title *Tishri* ("Imperial Preceptor") on Pagpa Lama, Sakya Pandita's nephew and heir. Pagpa finalized the Mongol alphabet which was used for a century.

When this Mongol dynasty collapsed in 1368, Sakya power was on the wane in central Tibet. Members of rival monastic orders such as the Karmapa had also been present at Kublai's court. In central Tibet, still another religious order, the Drigung pa, had revolted against Sakya control. The Sakya order retained political control of their own monasteries south and west of Shigatse, and their religious influence at Derge in east Tibet endured to the twentieth century. Kublai had granted the family of one of Pagpa's attendants administrative power over Derge, whose territory would eventually encompass 78,000 square kilometers.[12] This was the beginning of what was to become an increasingly autonomous cultural center at Derge, replete with monastery, cathedral, printing facilities and autonomous administrative power as well. Derge was linked to Lhasa by matrimonial alliances while religiously aligned with Sakya.

12. Joseph Kolmaś, *Geneology of the Kings of Derge*, p. 22. The Sakya order's influence in Gyantse into the fifteenth century is evident in the great monastic complex built by them in 1425. See Tucci, "Gyantse ed i suoi Monasteri," *Indo-Tibetica IV*, part 1, pp. 39–40, 73–93.

The consequences of the decline of Sakya power were pronounced in central Tibet where several religious orders and their noble patrons rivalled for economic and political control. The Sakya order's use of force against the Pagmogrupa, a Kagyu order and powerful principality in Ne'u dong, Yarlung, led to the complete defeat of the Sakya order in central Tibet by the mid-fourteenth century. The leader of the Pagmogrupa became known as the King of Tibet until the early seventeenth century. The influence of the Karmapa lama and his order was strong at the Ming court in China and in Kham, while the Gelugpa order, based in Lhasa, proselytized among Mongol tribes hostile to China.

The Gelugpa order, founded in the early fifteenth century by Tsong Khapa (*Tsong kha pa*, 1357–1419), received foreign royal patronage in 1578 when the Mongol prince, Altan Khan, gave the preeminent Gelugpa lama the title *Dalai Lama* ("Ocean of Wisdom" in Mongolian). Utilizing a new principle of succession which had slowly gained popularity since the Karmapa adopted it in the late thirteenth century, the Dalai Lama was considered a manifestation of divine forces, the embodiment of Tibet's spiritual protector, Avalokiteshvara. Sacred tradition in fact asserts that Songtsen Gampo, the first historic tsenpo, was also a reincarnation of Avalokiteshvara. Buddhists believe that an enlightened being can manifest in numerous reincarnations; with the transfer of this spiritual energy to a human body, the scheme of reincarnation took on new political ramifications.

At the beginning of the seventeenth century, Tibet was geographically divided along sectarian lines. Toh, Tsang and parts of Ü were controlled by the King of Tsang, who was aligned with the Karmapa order. The Gelugpa had their principal strongholds in and around Lhasa, but also had important centers at Kumbum in Amdo and Litang in Kham, both protected by Gushri Khan, leader of the Koshot Mongols who had established themselves in the Kokonor region. Sporadic fighting occurred between the factions from 1637 to 1642. With support from Gushri Khan, the Gelugpa leader, the 5th Dalai Lama (*bLo bzang rgya mtsho*, 1617–1682), succeeded in regaining control of Lhasa and routed his Tsang and Karmapa adversaries. In 1642, The Great Fifth (as he is called) unified Tibet, from Tatsienlu in the east to the Ladakh border in the west.[13] Lhasa was re-established as the capital of Tibet: in 1645 the Dalai Lama ordered the construction there of the Potala Palace, built on the ruins of a palace attributed to Songtsen Gampo. The 5th Dalai Lama showed astute diplomacy in renewing cultural ties with India, and in maintaining harmonious relations with the various Mongol factions and with the Manchu rulers of China. Within Tibet, even though he was the supreme Gelugpa authority, the Dalai Lama actively supported the foundation of several major Nyingmapa monasteries in Kham. The Sayka at Derge prospered as well during his reign. The Karmapa centers in Kham, notably at Likiang, were defeated and their canonical literature transferred to the Gelugpa monastery at Litang.[14]

The Great Fifth conferred the title of Panchen Lama on his principal Gelugpa teacher, and declared him to be the reincarnation of the Buddha Amitabha. The relation of the Panchen Lama to the Dalai Lama was

13. Tsepon W. D. Shakabpa, *Tibet, A Political History*, p. 111, states these boundaries, but Tucci, *Tibetan Painted Scrolls*, vol. II, p. 681 (note 52) cites the "Chronicle of the 5th Dalai Lama" that the Great Fifth's investiture was only over thirteen divisions of Ü-Tsang.

14. Yoshiro Imaeda, "L'edition du Kanjur Tibetain de 'Jang Sa-tham," *Journal Asiatique*, 1982, p. 181.

always, in theory, that of master to disciple, as Amitabha is considered senior to Avalokiteshvara in the divine hierarchy. In fact, as time passed, whichever of the two lamas was older became the tutor of the other. To a great extent, the role of the Panchen Lama was supposed to be purely spiritual, while the Dalai Lama embodied both spiritual and political authority. Although the 5th Dalai Lama had greatly consolidated his position, de facto Tibetan independence remained precarious due to the threat of the Manchu rulers of China and the Mongol tribes. Gushri Khan had stationed a permanent camp north of Lhasa. His support of the Gelugpa had earned the Koshot Mongol leader the hereditary title of "King of Tibet," although the 5th Dalai Lama was the actual ruler.

The death of the 5th Dalai Lama in 1682 was concealed by his close assistant, Sangye Gyatso (*Sangs rgyas rgya mtsho*, 1652–1705) for fifteen years in order to maintain the period of peace and stability. In 1695, the Potala Palace was completed, and in 1697, the 6th Dalai was at last officially enthroned. In 1702 the 6th Dalai Lama renounced his monastic vows, much to the dismay of the Panchen Lama and the other major Gelugpa lamas as well as Gushri Khan's heir, Lhazang Khan. A Manchu ally, Lhazang resented being kept from the secret of the 5th Dalai Lama's death. He advanced on Lhasa, assumed full political control by killing Sangye Gyatso and deposing the 6th Dalai Lama. Lhazang installed a new Dalai Lama who was not accepted by the Tibetan people. The Kokonor Mongols and the lamas of the Lhasa Gelugpa monasteries called on the Dzungar Mongols to divest them of Lhazang.[15] In 1717 the Dzungar lay siege to Lhasa, deposed the "false" Dalai Lama and killed Lhazang Khan. Their destruction of several Nyingmapa monasteries aroused the enmity of the Tibetans, but, above all, the Dzungar were unsuccessful in their attempts to restore the rightful Dalai Lama, born in Litang in 1708. Sheltered first in Derge, then in Kumbum, the 7th Dalai Lama was enthroned following a Manchu military expedition in 1720 to squash the Dzungars.

The Manchu withdrew their troops from Lhasa in 1723, retreating to the east where they annexed the Kokonor region in 1724.[16] The political administration and boundaries of Kham were redefined in 1725 as the next move in Manchu designs on Tibet.[17] Using a branch of the Yangtse River as a rough divide, Lhasa controlled all territory west of the river while, to the east, under Chinese protection but autonomous local administration, twenty-five semi-independent native states or principalities were recognized. Derge was the wealthiest and most important of these. A pillar on the Bum La pass, about sixty miles southwest of Batang, served to demarcate the boundary which extended due north to Kokonor. Internal governmental rivalries between the Lhasa cabinet ministers and the 7th Dalai Lama's father (for the Dalai Lama was but an adolescent at the time) led to a civil war in central Tibet in 1727–28. The rival parties appealed to the Manchu who sent an army to restore order. By the time the Manchu troops arrived in Lhasa, a former ally of Lhazang Khan, the cabinet minister Pholhanas (*Pho lha nas*, 1689–1747) had al-

15. Kolmaś, *Tibet and Imperial China*, p. 32; Shakabpa, p. 135.

16. Kolmaś, *Tibet and Imperial China*, p. 42, noting that the loss of Kokonor and Kham meant a reduction in Tibetan territory by almost half.

17. Eric Teichman, *Travels of a Consular Officer in Eastern Tibet*, pp. 2–3; Kolmaś, *Tibet and China*, p. 41; Luciano Petech, *China and Tibet in the Early Eighteenth Century*, p. 90 gives the comprehensive discussion of the period.

ready established his supremacy. Pholhanas received Manchu support in the form of two *amban* (imperial representatives) accompanied by an armed garrison. Pholhanas governed so ably that the garrison was reduced to only five hundred men by 1733 and the role of the amban became purely nominal.[18] The Dalai Lama had been exiled to Litang from 1729 to 1735, officially to be safe from the Dzungar menace.[19] He returned to Lhasa, exercising a purely religious authority while Pholhanas ruled until 1747. After Pholhanas's death, the Dalai Lama reasserted his authority over all secular and religious affairs, assisted by a cabinet of three lay ministers and one monk. The presence of the amban was maintained in Lhasa to the end of the Manchu dynasty.

The Manchu protectorate of Tibet was tempered in the eighteenth century by the Ch'ien Lung Emperor's official adoption of Tibetan Buddhism. Invitations and munificent gifts were proffered upon Tibetan clerics and patronage extended to the publication of a new edition of the canonical literature, printed in the Tibetan language in Beijing. North of Beijing, Ch'ien Lung constructed a summer capital at Jehol with replicas of the Potala Palace and other important Tibetan monuments.

In 1774–75, the Panchen Lama had the first official contact with a British representative by acting as intermediary between the Bhutanese and the British.[20] Thirteen years later, Tibet became embroiled in a trade dispute with Nepal, and in 1791, when the Nepalese sacked the Panchen Lama's Tashilhunpo monastery and occupied nearby Shigatse, it was the signal for Manchu intervention. In 1792, a combined Manchu-Tibetan army defeated the Nepalese and crushed the dissident Karmapa forces in Tsang who had supported this breach of Lhasa authority. The amban's power increased in consequence, for at least a few years.[21]

During the major part of the nineteenth century, the status quo of Lhasa authority and nominal Manchu protectorate was maintained. In China weak emperors followed Ch'ien Lung. The tottering Manchu regime was threatened by internal rebellions and intervention by European powers. In the mid-nineteenth century, border and trade disputes with Ladakh and Nepal led Lhasa into contact with British India.[22] The Lhasa government was headed by regents during the reign of several Dalai Lamas: the 8th, who was predominantly interested in religion, and the 9th through 12th, who died prematurely.

In Kham, at this time, the local chief of Nyarong had been encroaching upon the lands of other native chiefs, even as far as Litang, and succeeded in conquering the neighboring states of Derge and Hor. In 1863–64, when the Sichuan provincial authorities failed to block these invasions, Lhasa sent troops to do so, defeating the Nyarong chief in

18. Garrison figures from Kolmaś, *Tibet and Imperial China*, p. 41; Richardson, *A Short History of Tibet*, p. 53, points out that the Pholanas was now resented by the Tibetans because he did not openly oppose Chinese overlordship of Tibet.

19. Petech, *China and Tibet*, p. 174.

20. Prior to this, due to the simple fact of distance, very few Europeans had ever reached Tibet. Jesuit missions were briefly established at Tsaparang and Shigatse in the early seventeenth century. Italian missionaries — Jesuit and Capuchin — had even built a church in Lhasa during their residence from 1707 to 1745. But concomitant with the Mauchu protectorate, Tibet closed its borders to all foreigners other than the Chinese.

21. Kolmaś, *Tibet and Imperial China*, pp. 47–48.

22. Shakabpa, pp. 176–181, for details of the Ladakhi war; Kolmaś, *Tibet and Imperial China*, p. 52, for date of annexation by Britain; Shakabpa, pp. 181–2, for details of the war with Nepal in 1855 to 1856.

1865. The Chinese emperor granted the Dalai Lama control of Nyarong and Derge, although the Derge prince retained his title. Nyarong revolted again in 1894. This time Chinese troops penetrated into Nyarong, occupying most of the country. From Nyarong the Chinese forces reached Derge, in the midst of a succession dispute, and the royal family was imprisoned. A settlement was reached in late 1897, reinstating Lhasa rule of Nyarong, and resolving, temporarily, the Derge succession.[23]

In Lhasa, the government of the 13th Dalai Lama (1876–1933) was increasingly preoccupied with international relations despite Manchu encouragement to maintain an isolationist foreign policy. Certain factions of the Lhasa government believed that the British would destroy their religion.[24] Tibet had a direct border with the kingdom of Sikkim, subject to British protectorate since 1850. In 1885 the Manchu granted authorization for a British expedition to China via Tibet but the Tibetans refused the British access to their territory. In 1888 the Tibetans and the British clashed briefly at the border of Sikkim, leading to a Sino-British agreement in 1890 to redefine the border and recognize British interests in Sikkim. Trade access was thus established but remained problematic. Curiously, while British overtures were being refused, a pro-Russian Buriat Mongol monk named Dorjiev had considerable personal influence as one of the Dalai Lama's councilors. In 1898 he visited Russia whence he returned with presents for the Dalai Lama and the message that, as China was weak, Tibet should turn to Russia for alliance. The Dalai Lama was invited to visit Russia, but the Tibetan Assembly opposed the journey. Instead, Dorjiev, received by the Czar as "Envoy Extraordinary of the Dalai Lama," journeyed again to Russia and back.[25] Tibet's strategic position at the heart of Asia became crucial to British, Russian and Chinese schemes for the continent.

In 1903 a British military expedition led by Colonel Younghusband entered southern Tibet in order to force Lhasa into opening trade discussions and to counter Russian influence. Bhutan and Sikkim urged Lhasa to negotiate but to no avail. The expedition crossed the Sikkimese border, lay siege to Gyantse for three months while awaiting a Tibetan party for negotiations, and finally descended on Lhasa in August, 1904. Having authorized the regent to negotiate, the Dalai Lama fled to Mongolia, already under Russian influence. This seemed to confirm the worst of British fears, but within a month an agreement was signed by the Tibetans, authorizing a British trade agent to remain in Tibet and guaranteeing Tibetan compliance with previous Sino-British trade conventions. The British had sought direct negotiation because, as their representative explained, "We regard Chinese suzerainty over Tibet as a constitutional fiction — a political affectation which has only been maintained because of its convenience to both parties."[26]

The Dalai Lama remained in Mongolia more than a year, then travelled to Kumbum, the important Gelugpa monastery near Lake Kokonor. Here he received a message from Lhasa urging his return, and an imperial

23. Petech, *Aristocracy and Government in Tibet*, p. 178 for the invasions of Litang and Derge. The best source for the Nyarong rebellion is Tashi Tsering, "A Preliminary Study in Nyagrong Gompo Namgyel," *Proceedings of the International Association for Tibetan Studies*, Columbia University Seminar 1982, B.N. Aziz and M. Kapstein, eds. (publication pending).

24. Shakabpa, p. 206.

25. Richardson, *Short History*, p. 82.

26. Letter from Lord Curzon, Viceroy of India, quoted in Shakabpa, p. 219.

invitation from Beijing. In the hopes of reversing the Chinese policies in Kham, the Dalai Lama went to Beijing. To counterbalance their loss of face from the Younghusband expedition, the Chinese had established the new post of Imperial Resident in Chamdo in eastern Tibet. En route to Chamdo, the Resident stopped first in Tatsienlu, capital of the autonomous state of Chala, where he deposed the King. He then proceeded to Batang, where he took up temporary residence and attempted to interfere with Gelugpa control of the area. The monks led a revolt and the Resident was killed. A general uprising of all the monasteries in Kham ensued. A Chinese punitive mission from Sichuan razed the Batang monastery and executed the Tibetan headmen in retaliation. Chao Er Feng was appointed to regain Chinese control of eastern Tibet and he soon earned the nickname "Chao the Butcher" for his aggressive actions against local Tibetan authorities. In autumn, 1908, Chao took his turn at resolving the long-standing succession dispute at Derge. By the summer of 1909, Chao, having secured Chinese control of Derge, started for Chamdo, the eastern gateway to central Tibet. With troops from Batang and Derge, Chao occupied first Chamdo, then Draya and Markham. Only Nyarong remained an obstacle.[27]

27. Kolmaś, *Tibet and Imperial China*, pp. 54–65; Teichman, pp. 19–27.

FIGURE 6

The 13th Dalai Lama, portrait photo taken in studio of Th. Paar, Darjeeling, during the Dalai Lama's stay there, ca. 1910–12 (I22-C)

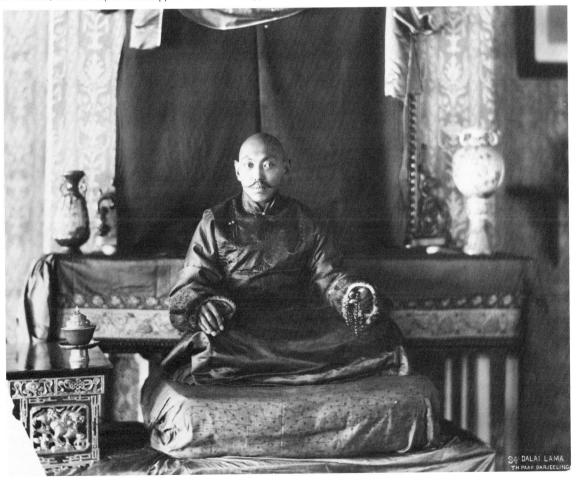

Using the northern route via Kumbum, the Dalai Lama returned to Lhasa in December, 1909. Lhasa sent public appeals to Europe and Beijing to stop the advance of the Chinese forces but to no avail. In February, 1910, Chinese troops invaded Lhasa. This time the Dalai Lama sought asylum in India, and in Beijing the British officially protested violation of the conventions in Tibet.[28] One contingent of Chao's troops advanced west of the Salween into the Brahmaputra basin, while another took Kanze, just outside of Nyarong. Chao forcibly annexed Nyarong in the spring of 1911, completing his control of Kham. He would have organized this area into a new Chinese province called Hsi Kang but in December, 1911, Chao was executed as the Chinese revolution broke out. Taking advantage of China's chaotic political situation, Lhasa forces overcame the Chinese troops stationed in central and southern Tibet, and uprisings occurred in Kham. The republican successor to Chao Er Feng looted Tatsienlu where he burned the Chala Palace, then destroyed the Chamdo monastery and reinstated Chinese control of Batang, Chamdo, Derge and Kanze.[29]

The Dalai Lama returned to Lhasa in January, 1913, and issued a declaration of independence. A tripartite British, Chinese and Tibetan conference was held in 1914 at Simla to attempt to resolve the boundary issues. Despite the initial approval of all parties, only the British and Tibetan governments ratified the agreement.[30] A tentative settlement was reached dividing the disputed territories roughly along the 1725 Bum La boundary, but leaving the monasteries of Batang and Litang (inside "Chinese" territory) in Tibetan control. Hostilities along the border led to a new mediation in 1918, upholding Tibetan claims to Chamdo, Draya, Markham and Derge, while ceding Batang, Litang, Nyarong and Kanze to China. Further negotiations occurred in 1932, reinstating the 1918 "armistice line." The Dalai Lama remained suspicious of Chinese movements in Kham and warned, just before his death, of the coming danger of Communism to the Tibetan religious order. The death of the 13th Dalai Lama in December, 1933, offered the Nationalist government of Chiang Kai-shek, whose earlier overtures to Lhasa had been rebuffed, the opportunity to make the first official Chinese visit to Lhasa since the invasion of 1910. After offering condolences and gifts to the Lhasa government, the Nationalists proposed that Tibet become a part of China. This was rejected and the Chinese mission departed leaving in Lhasa a small Chinese garrison and a radio transmitter. In 1934, a local uprising against Lhasa authority occurred in Kham, drawing Tibet into negotiations with Chiang Kai-shek's government. At the same time Mao Tse-tung's Communist troops, fleeing central China, attempted to enter Kham but were turned back by Tibetan government soldiers.[31] The Panchen Lama, in China since 1923, had become a protege of China.[32] When the Panchen proposed to return accompanied by five hundred Chinese troops, Lhasa was obliged to refuse him access unless the troops remained in Chinese territory. The Panchen traveled toward Tibet, but

28. Richardson, *Short History,* p. 98.
29. Teichman, pp. 29–42.
30. Kolmaś, "The McMahon Line: Further Development of the Disputed Frontier," *Tibetan Studies in Honour of H.E. Richardson,* points out in note 8, p. 183, that in fact the Tibetan and Chinese plenipotentiaries both *signed* the map and the convention; it was however, never ratified by the Chinese government.
31. Shakabpa, p. 278.
32. Richardson, *Short History,* p. 144.

died suddenly in 1937 in Jyekundo. In 1939 the 14th Dalai Lama was found in the Kokonor region, administered by the Chinese since 1724 but ethnically and culturally Tibetan. Lhasa paid a substantial ransom to the local authorities in order to obtain his passage from China.

During World War II, Tibet remained strictly neutral, refusing both Chinese and British requests to transport materials through Tibetan territory. A threatened coup d'etat was aborted in Lhasa in 1947.[33] The capital was still reeling from the rivalries among the monasteries when Mao, in 1949, announced by radio that Tibet would soon be "liberated." In October, 1950, Chinese Communist forces attacked several areas of Kham and simultaneously invaded northeastern Tibet and Changthang. Lhasa sent messages to the United Nations to protest the invasion, but no official action was taken. The Dalai Lama sought asylum to the south near the Sikkimese border in order to avoid being taken prisoner. A settlement was negotiated by the former Tibetan governor of Chamdo, who now became a Chinese puppet. The settlement guaranteed the status of the Tibetan government and the safety of the Dalai Lama (now persuaded to return to Lhasa) as well as the protection of established religious customs, but admitted Chinese military occupation of Tibetan territory. The Dalai Lama returned to find that by 1951 there were twenty thousand troops stationed in and around Lhasa alone.[34]

FIGURE 7

Si-lon Yab-shi Lang-dun, Prime Minister of Tibet, Lhasa. Photo: Cutting, 1937 (I20-C)

33. Richardson, "The Rva sgreng Conspiracy of 1947," *Tibetan Studies in Honour of H.E. Richardson*, provides an excellent account of the circumstances surrounding these events.
34. International Commission of Jurists, pp. 288–311.

In 1954 the Dalai Lama and the Panchen Lama[35] visited Beijing in an attempt at conciliation with the Chinese government. Despite the 1951 agreement the Chinese had begun to implement "reforms:" confiscation of large estates, deportation of children to China, assaults on the clerics and desecration of the monasteries, along with taxation to an extent hitherto unknown. Demonstrations against the Chinese accompanied active guerilla warfare which spread throughout Tibet, instigated in Kham where "reforms" had inflicted the most economic hardships and personal humiliation on the population. The Dalai Lama and the Panchen Lama visited India in 1956 and there met with the Chinese on neutral ground to request removal of Chinese troops, restoration of the status existing at the death of the 13th Dalai Lama, and abandonment of the Chinese program of reforms.[36] The only Chinese concession was a moratorium of five years in the implementation of the reforms planned for Tibet. Tibet remained occupied and in a constant state of guerilla warfare. By early 1959, Tibetan guerillas controlled most of southern Tibet. The Chinese pressured the Dalai Lama to use Tibetan troops to crush the resistance movement, composed largely of men from Amdo and Kham.

The Dalai Lama fled Lhasa in disguise on the night of March 17, 1959, receiving protection from the guerillas as soon as he crossed the Tsangpo River. He continued to India where he was granted political asylum. The Chinese troops in Lhasa shelled the Norbu Linga, the Potala and other strategic sites and installed a military government. Approximately one hundred thousand Tibetans followed the Dalai Lama to India.[37] In September, 1959, the question of Tibet was at last discussed in the United Nations but no official sanctions were taken. The guerilla movement continued unabated throughout the sixties, while further land and civil reforms were enacted.

The Dalai Lama established a government in exile at Dharamsala, India. The flood of refugees continued to swell, bringing news with them of atrocities in Tibet. The International Commission of Jurists stated in their report that acts of genocide had been perpetrated in Tibet by the Chinese.[38] Tibet was particularly hard hit by the Chinese Cultural Revolution and its after-effects of ca. 1965–75. Out of some three thousand monastic establishments in existence prior to 1959, only a handful remain today, essentially as museums. Since 1980 some international journalists and tourists have been allowed into Lhasa. The Lhasa Cathedral is reopened for public worship and portions of the Potala Palace are opened to visitors. The guerilla movement seems to have been suppressed, yet Tibetans inside and outside their country yearn for their independence and freedom to practice the religion which has been the matrix of their culture.

FIGURE 8

The 14th Dalai Lama, ca. age 10. Photograph sent to Cutting in 1945 with the greeting: "In accordance with the authorization of the Buddha, this is the 14th Dalai Lama, immutable holder of Vajra and master of the completely perfect teachings." (Cutting gift 1982, 82.90)

35. This disputed incarnation of the Panchen Lama was born in 1938 in Qinghai and his recognition supported by the Chinese government which circumvented traditional Tibetan confirmation procedures. See Shakabpa, p. 306.

36. Richardson, *Short History*, p. 203.

37. In regard to Tibet's other major religious leader, the Panchen Lama, already aligned with the Chinese (Shakabpa, pp. 306-7, 310-11), remained at Tashilunpo, his historic seat, following the events of 1959; later he became vice-president of the Committee for the Autonomy of Tibet, the highest Communist Party organ in Tibet. In 1964, the Panchen Lama "disappeared" only to resurface again in 1979–80 when he was elected, in Beijing, as vice-chairman of the Minority People's Congress.

38. International Commission of Jurists, pp. 288–311.

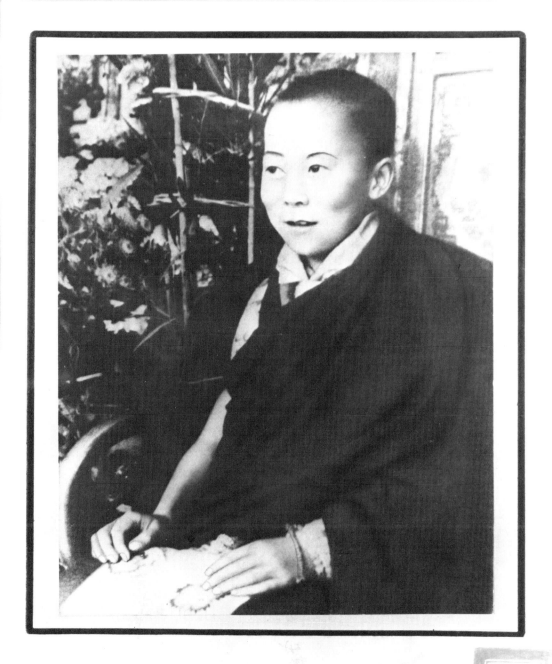

༄༅། །ཁ་རག་རྒྱུད་ཀྱི་བཀའ་འི་ལུང་གིས། རྒྱལ་བའི་བསྟན་ཡོངས་རྫོགས་ཀྱི་བདག་པོ་འཇམ་དཔལ་རྡོ་རྗེ་འཆང་དུ་བའི་བླ་མ་དཔལ་དང་བཅུ་བ་ཞི་མཆོག་པོ།

III. RELIGION

1. Buddhism

Prior to 1959, Tibet was governed as an ecclesiastical state according to the principles of Buddhism. This religion was founded in northern India during the sixth century B.C. by Shakyamuni, known by epithet as Buddha, "The Enlightened One." His teachings concentrated on the alleviation of the suffering inherent to the impermanence of life and man's unfulfilled desires. The ethical system proposed by Shakyamuni focused on the accumulation of good moral deeds and the development of a wise and disciplined mind. The goal of the accumulation of good deeds is to purify the mind and ensure a positive rebirth in which it will be possible to attain salvation. The world of *samsara* including divine, human, animal and infernal realms, is conceived of as involving suffering in all of its aspects. To be born as a human is considered best because only man can aspire to Buddhahood. The doctrine of rebirth was common in India at the time. Shakyamuni opened the road to salvation for all, regardless of caste, who followed his precepts.

His first teaching was encapsuled in the "Four Noble Truths:" 1) *Dukkha* (suffering), the fundamental nature of all conditioned existence is suffering, and 2) *Samudaya* (the cause and arising of suffering), the origin of suffering is unfulfilled desire coupled with *karma* accumulated in this and past lifetimes. Suffering and the origin of suffering are basic philosophical concepts of Buddhism. Suffering can be understood as the obvious suffering of daily life such as illness, loss and death, and, on a more profound level, as the suffering arising from the inevitable impermanence and interdependence of existence. It is this impermanence and interdependence on all other phenomena that is meant in the phrase "conditioned existence." After years of searching Shakyamuni finally discovered the state of unconditioned existence, which is 3) *Nirvana* (the cessation of suffering), to be attained by eliminating desire and karma. 4) *Marga* (the path), the way leading to nirvana, is the "Noble Eightfold Path." This consists of: 1) Right Understanding, 2) Right Thought, 3) Right Speech, 4) Right Action, 5) Right Livelihood, 6) Right Mindfulness, 7) Right Concentration, and 8) Right Views. To practice the Eightfold Path, Buddhists take refuge in the "Three Jewels:" the *Buddha*, the *Dharma* (the Buddhist sacred philosophical and moral code), and the *Sangha* (the community which upholds these values).

If one followed these principles, moral imperfections acquired in previous lifetimes could gradually be cleared and no further defilements would accumulate as the individual continued his course toward nirvana. According to the Buddha's explanations, everything is impermanent, composed of transient aggregates in a state of constant flux and mutual conditioning. Due to the intrinsic composite nature of everything, it is said that everything is void of inherent existence. This is the Buddhist doctrine of emptiness or *sunyata*. Thus physical elements and mental attitudes, and the very ego itself are all impermanent, but in the normal everyday world (termed *samsara*) these aggregates (including the perception of the self) are perceived by un-enlightened beings as real and constant. When nirvana is realized the transient nature of the aggregates is fully perceived, ignorance, craving and hatred are eliminated, and enlightened awareness is achieved.

In the first centuries after Shakyamuni's death, divergent interpretations

FIGURE 9

Chortens, Kham. Photo: Shelton, ca. 1905–20 (D32-S)

of the nature of reality and of nirvana led to the establishment of different sub-schools of Buddhism. Theravada, an early school still practiced in Ceylon and Southeast Asia, maintains that nirvana is distinct from the world as we know it. The Mahayana tradition (the "Great Way," founded ca. second century A.D.) postulates that nirvana is attainable in this world and is not, in the final analysis, different from samsara. Nirvana and samsara are related like the two sides of a coin, all a matter of how we perceive the phenomenal world. If we are able to fully apprehend the doctrine of emptiness, which expounds the composite nature of the interdependent, impermanent elements consituting the phenomenal world, then we could live in a state of nirvana even while we are in this physical body. But herein lies a fundamental distinction between Mahayana practice and Theravadin practice. The Theravada school stresses the personal enlightenment of the individual, as epitomized by the *Arhat*, a Buddhist monk who achieves the highest state of perfection. By practicing monastic discipline in accordance with the sermons of the Buddha (*Sutras*) and appropriate meditation on the impermanent nature of reality, the Arhat realizes nirvana and will no longer be reborn. In Mahayana teachings, the practitioner emulates the *Bodhisattva* striving for the collective salvation of all sentient beings. A Bodhisattva ("Enlightenment Being") delays his own nirvana in order to assist others in their attainment of enlightenment.[1]

As Mahayana developed, the concept of the nature of Buddha, The Enlightened One, became increasingly abstract. Shakyamuni, the historic Buddha of our age, came to be considered as one of over a thousand Buddhas which will appear in the course of this aeon (*Kalpa*). The idea of a series of appearances in this world by successive Buddhas was extended further in India in the first to second centuries by the idea of a plurality of Buddhas in one time span. Buddhahood thus came to be seen as a universal principle. Five main Buddhas representing Buddha families developed: Vairocana ("Resplendent") at the center, with Amitabha ("Boundless Light"), Akshobhya ("Imperturbable"), Amoghasiddhi ("Infallible Success") and Ratnasambhava ("Jewel-born") radiating out as the four cardinal points.

Concomitant with Mahayana, Vajrayana Buddhism developed, centered on the Buddha's doctrine as expounded in the group of texts called *Tantras.* These texts teach the transformation of all actions and emotions in the path toward Buddhahood which, according to Vajrayana, may be reached in one lifetime by a particularly direct path. The path involves disciplined concentration through yoga practices which enable an individual to gain control over his body and his mind. The practices include contemplating external objects such as images of deities which help to purify the body, speech and mind. An icon reflecting tantric Buddhist concepts which occurs frequently in painting and sculpture is the *yab-yum* image. In such an image, the ecstasy of nirvana is described in analogy to human sexuality: the male figure (termed *yab*, "father") represents active compassion, and the female figure (termed *yum*, "mother") represents transcendental wisdom. The union of these complementary forces is the essence of the enlightened mind.

The *Tantras* provide rich iconographic sources by their description of

1. David Snellgrove, *Buddhist Himalaya,* gives an excellent overview of the development and the doctrines of Buddhism. See also, Walpola Rahula, *What The Buddha Taught,* and Edward Conze, *Buddhism: Its Essence and Development.*

deities and their realms. But the very philosophical doctrines of Buddhism made the existence of deities possible only if the deities represent manifestations of consciousness. Buddhism is atheistic in philosophy but may be polytheistic in practical worship, depending upon individual preference. In addition to a deified Shakyamuni and other Buddhas, the religion gradually incorporated many early Indian Hindu deities into the pantheon.

Buddhism as practiced in Tibet is the integration of Theravada, Mahayana and Vajrayana philosophies in conjunction with indigenous Tibetan beliefs and ritual practices, assimilated into a Buddhist conceptual framework. The different orders which evolved within Tibetan Buddhism (to be discussed below) reflect emphasis either on mystic meditation or on intellectual insight as the foundation of meditation, but all adhere to the basic Buddhist tenets.

2. The Indigenous Religion

Before the introduction of Buddhism in the seventh to eighth centuries A.D., Tibetans believed in a divinely ordered universe over which a deified ruler, the tsenpo, presided. It has been proposed that this religion was called Tsug (gTsug), the term used for the divine order of the universe.[2] The sacred character of the early tsenpo is attested by numerous early documents and contemporary inscribed stele. The persona of the ruler had a personal guardian deity, the Kula (sKu bla)[3] identified with a sacred mountain and worshipped by the populace to ensure their prosperity, through the practice of herbal burnt offerings. As a human manifestation of divine presence, the tsenpo first appeared on earth as he descended from a sacred mountain. The Kula is thus identified as a divinity/mountain, and as an ancestor and support of the vital principle of the tsenpo, who reunited with his Kula upon burial in a tomb called "mountain." There the tsenpo's remains awaited rebirth in a joyous paradise when a final resurrection would occur. Funeral ceremonies were elaborate, including ritual sacrifice of animals performed by priests called *Bonpo*.[4] Deification of the tsenpo and the mountains was accompanied by precise divination rituals, celebrated by priests called *shen*. The social ideal of human justice and equality through equal distribution of resources were part and parcel of the divine order which the tsenpo preserved. The organized Tsug religion appears to have been practiced

2. Both Rolf A. Stein, *Tibetan Civilization*, and Giuseppe Tucci, *The Religions of Tibet*, discuss the ideas and practices of the indigenous Tibetan religion, but the first study to establish the term Tsug and the most comprehensive discussion is Ariane Macdonald, "Une lecture des P.T. (Pelliot Tibétain) 1286, 1287, 1038, 1047 et 1290. Essai sur la formation et l'emploi des mythes politiques dans la religion royale de Sroń bcan sgam po."

3. The term Kula (sKu-bla) is of prime importance, as the core term *bla* is pronounced "La", signifying "life force." Recent scholarship has shown the relation of this term with the word lama (*bla-ma*) signifying "spiritual master." The lama is of such importance in Tibetan Buddhism that the religion itself is often referred to as "Lamaism." See Ariane Macdonald and Yoshiro Imaeda, *Choix de Documents Tibétains Conservés à la Bibliothèque Nationale*, vol. II, pp. 12–15.

4. The term for funerary priests specialized in ritual sacrifice (*Bonpo*) has often been erroneously confused with two later concepts: the organized religion called Bon, whose adherents are called Bon po and individual exorcist priests (*dBon-po*) who practice outside of any organized Tibetan religion. Because these terms are almost homonyms, many early European visitors to Tibet thought that the pre-Buddhist religion was the shamanism practiced by the *dBon-po*. The religion described in the Dunhuang manuscripts is not shamanistic. Also, the later Tibetan historical tradition linked the early organized royal religion with Bon, further confusing the matter.

in central Tibet and over a large extent of the Tibetan empire in the seventh to ninth centuries.[5]

The first historic tsenpo, Songtsen Gampo (reign 620–650 A.D.), is traditionally credited with the introduction of Buddhism to Tibet by virtue of his matrimonial alliances with a Chinese princess and a Nepalese princess. The two wives are held responsible for the tsenpo's conversion to Buddhism, and for the construction of the first Buddhist temples in Lhasa. Yet contemporary documents state that Songtsen Gampo swore to sacrifice (hardly orthodox Buddhist practice!) a hundred horses on the tomb of his faithful minister, evidence of his continued adherence to Tsug. In fact, recent scholarship indicates that it was Songtsen Gampo who codified the Tsug religion to ensure the stability of the empire and the royal government as well as to enhance the prestige of the royalty and their descendents.[6] By offering a total vision of the world and time, the tsenpo governed his subjects both in life and in the afterlife.

The concepts and practices of Tsug were fundamentally irreconcilable with the basic principles of Buddhism: the Tsug belief in an afterlife and resurrection versus the Buddhist belief in the impermanence of all existence; the Tsug ideal of human happiness versus the Buddhist concept of suffering related to existence; and immediate human justice versus the cycle of rebirths and karma. The Tibetan tsenpo were at first inclined to support both religions despite the apparent contradictions and the fact that the adoption of the doctrines of Buddhism imperiled their divine right to rule. The process of conversion was gradual, incorporating ideas from the many currents of Buddhism with which the Tibetans were in contact through their conquests in Central Asia, China and India, where Buddhism was firmly entrenched. The reverence formerly accorded to the deified tsenpo was transferred to a deified Shakyamuni Buddha, indigenous deities were incorporated into the Buddhist pantheon, and the live sacrifices previously offered were replaced by dough effigies.

3. The Early Development of Buddhism and Bon in Tibet

During the reign of Songtsen Gampo's great-grandson, Trisong Detsan, 755–797/98, Buddhism made great strides in the conversion of the Tibetans. In 779, with the help of foreign religious masters, Trisong Detsan founded the first Buddhist monastery at Samye, about fifty miles southeast of Lhasa. Two great teachers came to Tibet at this time: the Indian master, Santaraksita, who preached a form of Mahayana Buddhism, emphasizing meditation and meritorious acts leading to a nirvana achieved gradually over many lifetimes; and Padmasambhava, a native of Oddiyana (now thought to be the Swat Valley, Pakistan), who practiced Vajrayana Buddhism, accentuating tantric ritual meditation to attain nirvana in just one human lifetime. Padmasambhava is traditionally revered for miraculously subduing the indigenous Tibetan deities, and incorporating them into the Buddhist pantheon. The invitation of these two religious masters indicates the persistence of Tsug and the early Tibetan appreciation of the complementarity of Mahayana and Vajrayana teachings and methods: in the collaboration of Santaraksita and Padmasambhava the philosophical, moralistic and rational trends of Ma-

5. Macdonald, "Une lecture des P.T.", p. 304.
6. Macdonald, "Une lecture des P.T.", p. 377.

32

hayana are integrated with the more ritualistic and mystical Vajrayana. The tsenpo Trisong Detsan recognized this by his edict establishing separate status for monks in monasteries and for tantric hermit adepts. Teachers of the Chinese Ch'an Buddhist sect proselytized at Samye as well, to such an extent that, according to tradition, a debate was held (ca. 797) to determine which Buddhist school Tibet would officially adopt. The Chinese priest was defeated, and thus Tibet opted for the Indian Buddhist teachings of Mahayana and Vajrayana.[7] Tradition aside, it is clear that several schools of Buddhist thought were known in Tibet during the seventh to ninth centuries, and that opposition to any form of Buddhism was also present in those who still favored the indigenous organized religion.

In the first half of the ninth century, three tsenpo in succession supported Buddhism and established by edict the basis for monastic power in Tibet: two Buddhist clerics were added to the tsenpo's councilors and property was allocated for monasteries, which were accorded a tax-exempt status and given financial support through taxation of the populace. In this period many Indian teachers were invited to Tibet both to preach and to undertake the arduous task of translating the Buddhist scriptures from Sanskrit into Tibetan, a project which was finally completed in the early fourteenth century. Among the first texts translated were the rules of moral code and monastic discipline (*vinaya*), certain Mahayana teachings dealing with the doctrines of emptiness (in particular, the *Perfection of Wisdom Sutra*), and some Vajrayana tantric rituals along with a large number of mystic prayers (*dharani*).

The indigenous religion was however not totally vanquished. In 822, during the reign of Tsenpo Ralpacan who was overtly pro-Buddhist, a major Sino-Tibetan peace treaty was concluded. Two ceremonies were held to seal the pact: one sanctified by Buddhist clerics and the other, a ritual animal sacrifice.[8] The successor to Ralpacan was Lang Darma who is ignominiously remembered in history for his severe persecution of Buddhism.[9] His assassination in 842 by pro-Buddhist adherents was the culmination of the competition for political and economic power. This final end to the tsenpo tradition caused a century-long period of political and religious realignment.

Buddhism had established strongholds in Amdo and in western Tibet when historical records resume in the mid-tenth century. Although the Tsug religion had lost its raison d'etre since there was no tsenpo, many of its deities and some of its rituals were diffused into Buddhist teachings, and into another religion, Bon, codified in the tenth to eleventh centuries. As a modern Bon po historian has said, "Bon had been in an embryonic state when the tsenpo were in power, blending three main elements: the worship of the divine nature of the tsenpo and the associated gods, Iranian ideas of the formation of the world, and sophisticated Indian theories such as karma and rebirth."[10] By its early assimilation of Indo-Iranian elements, Bon may have prepared the terrain for the adop-

7. According to Chinese sources, the Chinese priest in fact won, Anne-Marie Blondeau, "Les Religions du Tibet," pp. 252-253.

8. Stein, *Tibetan Civilization,* p. 200.

9. Blondeau, "Les Religions du Tibet," p. 254, mentions a Buddhist prayer for Langdarma among the Dunhuang manuscripts, despite the persecutions attributed to him.

10. Samten G. Karmay, "A General Introduction to the History and Doctrines of Bon," pp. 7–9.

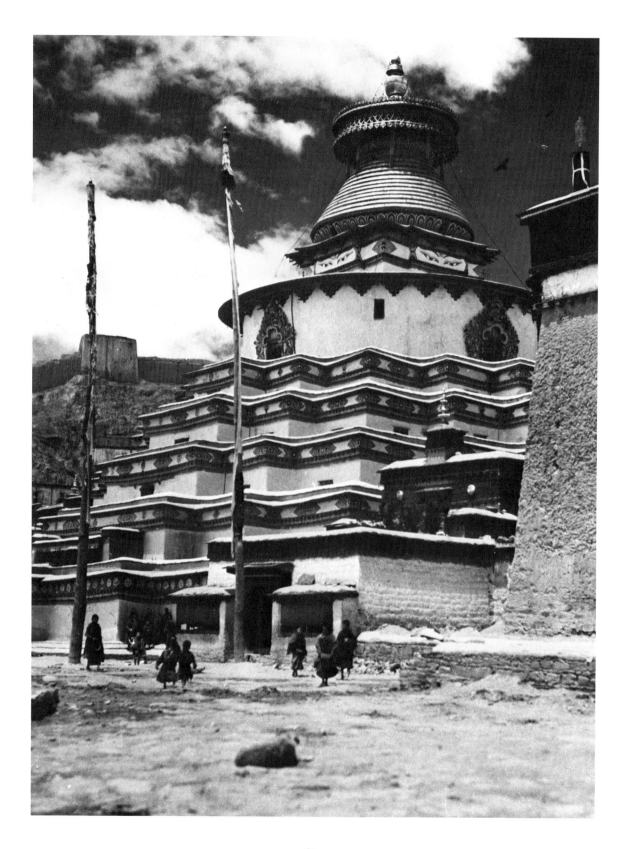

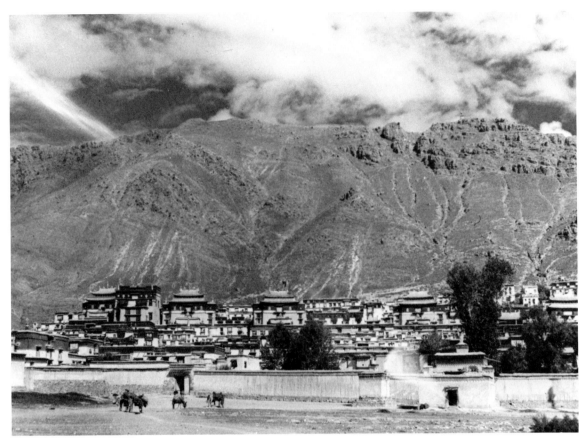

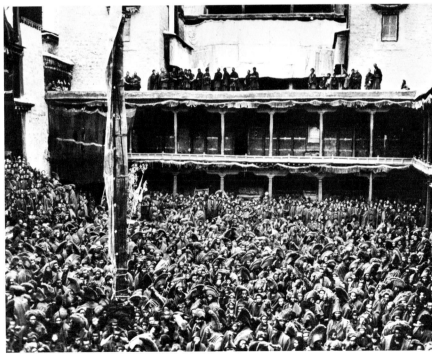

FIGURE 11 (Top)

View of Tashilunpo, founded in 1447 and used since the seventeenth century as the seat of the Panchen Lama, Shigatse. Photo: Cutting, 1935 (L59-C)

FIGURE 12 (Right)

Monks in courtyard, Tashilunpo, Shigatse. Photo: Cutting, 1935 (S2-C)

FIGURE 10 (Left)

The Great Chorten of Palkhor Choide, built ca. fifteenth century, Gyantse. Photo: Cutting, 1930 (M17-C)

tion by Buddhism of Tibetan deities and certain rites.[11] Bon texts of the tenth to eleventh centuries still include animal sacrifice, perhaps to be related to the functions of the Bonpo funerary priests who specialized in the ritual sacrifice known earlier in Tibet. But these same texts include many elements common to Buddhism. Bon as a religion still exists today, but it is practiced very much like other sub-schools of Tibetan Buddhism, despite maintaining its own terminology and a distinct and voluminous body of canonical literature. In southern Kham, the Bon converted the Mosso aboriginal tribes (also called Nga-khi) to their religion. In Tibet prior to 1959, most of the Bon monasteries were found in the western regions or in Kham, although one important monastery was near Lhasa. The Bon religion may be envisioned as an active counterpart to Tibetan Buddhism, organized and codified simultaneously and in parallel.

4. The Establishment of the Main Buddhist Sects in Tibet

In the late tenth to early eleventh centuries, there was a second diffusion of Indian doctrines into Tibet. Many new sects and monasteries were founded at this time. The Indian sage Atisha, who arrived in central Tibet in 1042 after a sojourn in western Tibet, found Samye largely neglected and many of the tantric teachings being practiced incorrectly. In response to this, Atisha advocated celibacy, abstinence, and stressed the relation of strict dependence on the individual teacher, the lama (*bla ma* or S. *guru*). Tantric rituals were included in Atisha's teachings but were reserved for a few initiates. Those who still followed the original teachings of Padmasambhava became known as "the ancients," the Nyingmapas, while

11. Stein, *Tibetan Civilization*, p. 263.

FIGURE 13

The Potala, Lhasa, during procession for the commemoration of the 5th Dalai Lama's death. Photo: Alexandra David-Néel, March, 1924 (M48)

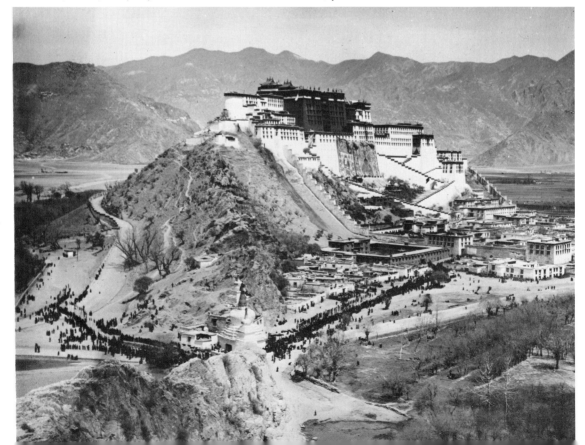

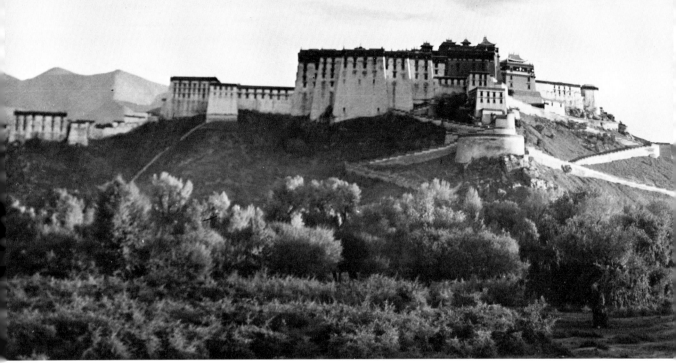

the followers of Atisha were known as "the adherents who absorb every word of the Buddha as having spiritual significance," the Kadampas. Shortly after the foundation of the Kadampa order, two other major orders were established. The Sakyapa order was founded in the eleventh century; named after their principal monastery in western Tibet, the Sakyapas dominated Tibet politically and spiritually in the thirteenth century under the patronage of Kublai Khan. The head lama's succession was passed from uncle to nephew. One of the three sub-schools was based at Ngor monastery, of particular importance for its distinctive art style. The Sakyapa teachings combined monastic discipline with tantric doctrines in a comprehensive curriculum.

The other major sect, Kagyupa, traces its origins to the Tibetan yogi Marpa who studied in India and returned to Tibet to practice as a married farmer. His disciple, Milarepa (1040–1123) is well known for his poetic accounts of mystic visions and encounters. Milarepa's disciple Gampopa founded the Kagyupa sect, which later divided into twelve suborders. Of these the Karmapa group came to have the most political power, perhaps for their innovative form of ensuring the succession by reincarnation. Great emphasis was placed on mystic meditation in all the Kagyupa groups.

In the tenth to thirteenth centuries, Buddhism was eradicated in India in part owing to the Moslem invaders, who systematically desecrated Buddhist shrines and destroyed the great monastic universities of northern India. Some Indian religious masters sought refuge in Nepal and Tibet. When the Tibetans could no longer travel to India to seek teachings, a system of revealing "hidden" texts (*terma*) flourished among the Nyingmapa. These texts, attributed to Padmasambhava, are revealed to chosen disciples through visions and recovery of the texts from their place of concealment. Longchenpa (1308–1363) organized a systematic approach to Buddhist philosophy and gave new impetus to the Nyingmapa lineages by combining terma teachings, tantric ritual and meditative techniques.

FIGURE 14

Potala, north (back) view, Lhasa.
Photo: Cutting, 1935 or 37 (M65-C)

Tsongkhapa, a great Buddhist scholar and reformer, was born near Kokonor in 1357. In reaction to the overly secular activities of some schools and to what he deemed a loosening of monastic discipline, Tsongkhapa created the Gelugpa order, modeled on Atisha's earlier Kadampa group. Tsongkhapa reaffirmed monastic discipline, and placed great emphasis on metaphysical debates as part of the monastic curriculum which integrated *Sutra* and *Tantra*, including colleges of astrology and medicine in some monasteries as well. Initially the Gelugpa were able to stay outside the political factions within Tibet, but when threatened, they turned for assistance to Mongol princes whom they had converted to Buddhism. The Dalai Lama came to be the title of their principal leader, and the Panchen Lama was the other major spiritual leader within the sect. By 1642, under the leadership of the 5th Dalai Lama the Gelugpa exercised both temporal and spiritual control over Tibet. Once the Gelugpa had established their hegemony in central Tibet, the other monastic orders tended to flourish outside the direct realm of Lhasa. In the next three centuries the religious fortunes of Tibet became inextricably bound to political events as discussed in the previous chapter.

FIGURE 15

The High Lama of Batang, Jö Lama at left, Batang, Kham. Photo: Shelton, ca. 1920 (159-S)

5. Monastic Life

There were approximately three thousand monasteries in Tibet prior to 1959, occupied by as many as twenty percent[12] of the adult male popula-

12. There are conflicting estimates on the percentage of the Tibetan population actually in monasteries.

tion. The monastic establishments varied in size from a few members to veritable towns of two to three thousand monks. Each monastery consisted of an assembly hall and a main temple as well as dwellings for the monks. The Gelugpa established the largest monasteries which were divided into residential colleges for purposes of specific study, i.e. schools of metaphysics, logic, astrology, medicine and advanced departments for specific ritual cycles and tantra. The monastic establishment had a role for everyone who kept the vows of the community. In addition to those novices showing intellectual promise who would embark on long academic or meditative training, there were monks who served as teachers, artists, clerks, commercial agents, cooks, bodyguards, almost every occupation necessary to a small society.

The monastic city was a sacred object in and of itself because it housed the clergy, venerated since earliest Buddhism as part of the Three Jewels. The sacred prestige of the monastery was increased by the presence of incarnate lamas, considered at birth to be the re-embodiment of a deceased eminent lama. Buddhists believe that an enlightened person can, upon his death, transfer his spiritual energy to a new human body. Thus the incarnate lama is sacred for his own spiritual qualities as well as those of the predecessor whom he embodies. A monastery could also be the seat of an official medium or oracle, consulted by the monks and the populace during religious festivals or in times of trouble.

As a complement to the celibate monks of the monasteries, non-

FIGURE 16

Tsogchen Dukhang (chapel), Sera Monastery, founded 1419, Lhasa. Photo early 20th century (M73-C)

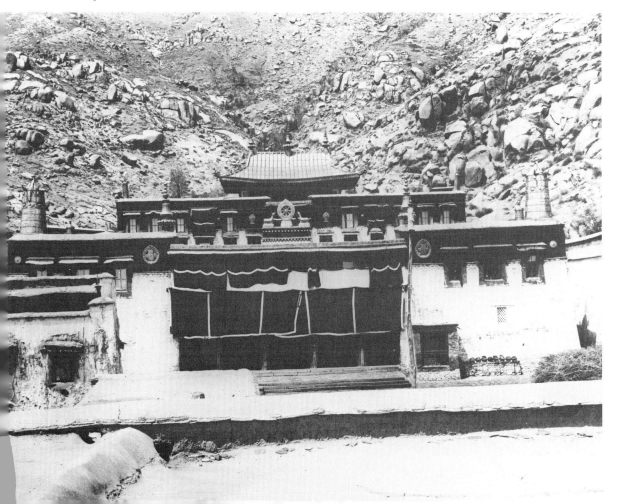

cloistered, self-styled religious adepts and a married clergy also existed in some religious orders. The cloistered monks took basic vows of celibacy and monastic discipline in addition to a Bodhisattva vow to strive for the salvation of all sentient beings or the Tantric vow to strive to attain this collective salvation in one lifetime. The married clergy were exempt from the monastic vows, but were equally venerated by virtue of either their Bodhisattva or Tantric vow, in addition to their individual spiritual devotion and scholarship.

The lay population called on the local monastic establishment, often in a coordinated effort with non-monastic priests, to officiate at occasions of birth, death and illness. Certain priests were held capable of influencing the weather and were thus requested to intercede to bring or stop rain, hailstorms or the like. If a village or family seemed in the throes of general misfortune, a lama would be called to determine the cause of the problem and eliminate it by ritual or appeasing the offended spirit with offerings of grain and libations. On the occasions of religious holidays which punctuated the calendar year, individuals would travel long distances to meet and trade, while the monks celebrated ritual services, and then all attended ceremonial masked dances performed by troops of monk-dancers.

6. Folk Religion

The lay populace demonstrated overwhelming faith in Buddhism while generally leaving questions of metaphysical or philosophical nature to the clergy. To this day, devotion is shown to all Buddhas and Bodhisattvas, most especially to Avalokiteshvara who is considered to be Tibet's patron. His six-syllable prayer, OM MANI PADME HUM, is counted on the rosary beads that the Tibetan never abandons, on the prayer wheel that he is wont to spin, and engraved on rocks or piles of stones along the

FIGURE 17

Appliquéd banner displayed once a year on Monlam Chemo ("Great Prayer Festival") in February, Labrang, Amdo. Photo: Griebenow, ca. 1922–40 (E2-G)

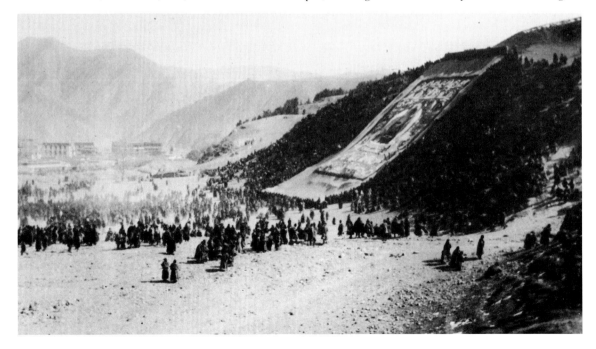

FIGURE 18

Women turning large prayer wheels, Labrang monastery, founded 1709, Amdo. Photo: Griebenow, ca. 1922–40 (D9-G)

FIGURE 19

Pile of stones with *mani* prayer carved and painted, Khampa nomad posing nearby, Kham, ca. 1908–20.

roadsides. Another expression of faith is the custom of making pilgrimages to sacred sites near and far. When approaching a *stupa*, the pilgrim will walk around it in a clockwise direction as a ritual devotion.

Buddhist worship is typically practiced within the family, clan or village. Most believers attend to their family shrines on a daily basis, for instance putting fresh water in the appropriate bowls every morning and lighting the butter lamps every evening. Certain days of the Tibetan month are especially auspicious; on the 8th, 15th and 30th days, one-day vows (sunrise to sunrise) of conscious virtue are taken. The 10th and 25th days of the month have special meaning for Nyingmapa and Kargyupa followers. In the fourth Tibetan month (May–June), fasting (forsaking meat) is done every other day by the pious. Important seasonal events of the year include the New Year and Harvest Festivals where morning chanting and evening religious readings frame days of secular celebrations. Each village in Tibet would also have scheduled summer camping parties in the mountains with prayer chanting to give a solemn start to the daily races, dancing and picnicking. In agricultural and pastoral settings, winter is a time of relative inactivity and those able would go in retreat to a mountain center. The religious activities at the center would be conducted by trained lay teachers or monks.

As an integral complement to these orthodox Buddhist practices, Tibetans also demonstrate beliefs and practices which stem from the Tibetan pre-Buddhist heritage. The many categories of demons and ghosts, mountain gods and earth spirits, deities who reside in the different parts of the human body, spirits of the house and of the herds must be propitiated on a day-to-day or yearly basis. Many of these spirits are worshipped by offerings of fumigation, in which sweet-smelling juniper branches are burned. Divination or consultation of the oracle are common means to determine if a spirit has been offended and how it should be appeased. These assorted deities and spirits are considered powerful in the terrestrial world and beyond and must thus be dealt with to ensure success in mundane matters, but they are subordinate to the supramundane Buddhist divinities.

These many aspects of Tibetan religion, as seen on the multiple levels of mundane family, tribe and village practices, and supramundane monastic rituals, will be discussed as they relate to specific objects in the Museum's collection. These will be found in volumes II (ritual objects, prayer, music), III (painting and sculpture), IV (religious textiles and costumes) and V (religious documents, manuscripts, books).

IV. SOCIETY

The previous chapters on geography, history and religion have discussed the unique nature of the Tibetan environment, the complex developments on the Tibetan plateau through recorded history, and the great importance of religion. This chapter will give a brief overview of the nature of secular life in Tibet in the first half of the twentieth century, when most of the objects in the Newark Museum collection were made and used.

The people spread so thinly over the austere Tibetan landscape were primarily engaged in agriculture. Pastoral (nomadic) activities involved a smaller percentage of the population. The fertile land lying in valleys, especially in central and southern Tibet, was divided up into hereditary estates owned by monasteries, aristocratic families, or the Lhasa government. Hereditary obligations to the central government were entailed in this ownership in the form of direct taxes or services. The aristocratic families, for instance, were obligated to have at least one son serve in the government bureaucracy. Smaller allotments of land owned by *tral-pa* (*khral-pa*; "tax payers") were subject to taxation and rendered services either to the central government or to local nobility or monastic authorities. In the larger estates, whether owned by the state, monasteries or aristocracy, the land was worked in small parcels by tenant farmers or landless laborers. Somewhat the same system was used to allocate pastureland and herds to the nomadic community, but in eastern and northern Tibet nomadic families had a greater amount of autonomy of movement than in areas more directly under the control of Lhasa. Still more independent aspects of the economy were money lending, trade

FIGURE 20

Harvest Festival, Milarepa play, dancing between dialogues, Batang, Kham. Photo: MacLeod, ca. 1920–30 (F3-M)

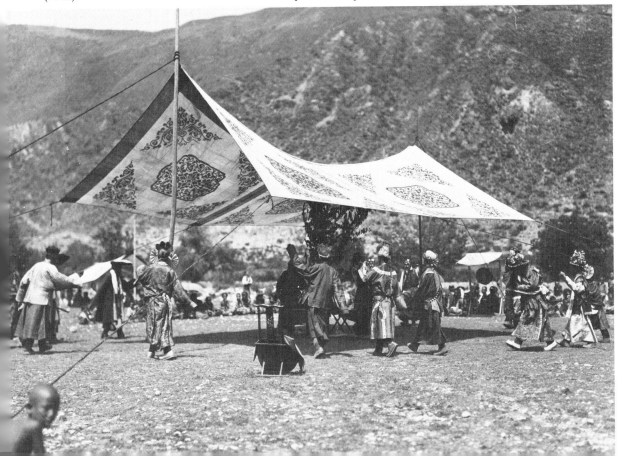

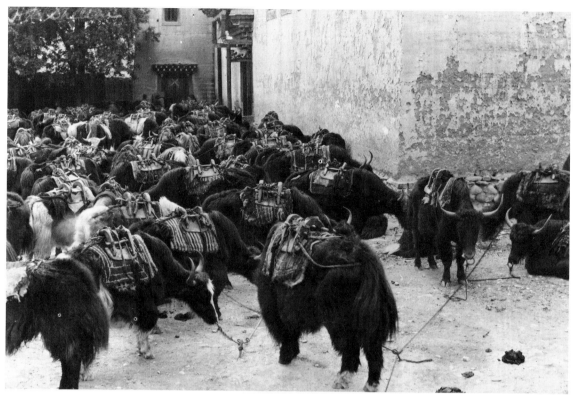

FIGURE 21 (Top)

Yak caravan ("house yaks" indicated
by ring in nose) used for local
transport, Kham/Sichuan border.
Photo: Shelton, ca. 1908–20 (O54-S)

FIGURE 22 (Left)

Tibetan nomads on ponies in town of
Labrang (Chinese townsman at door
of shop), Amdo. Photo: Griebenow,
ca. 1922–40 (O24-G)

FIGURE 23 (Top right)

Yak skin boats at Chakzam Drukha
ferry crossing, Tsangpo River, central
Tibet (Ü). Photo: Cutting, 1935 or 1937
(O28-C)

FIGURE 24 (Bottom right)

Threshing on roof of a house, Batang,
Kham. Photo: MacLeod, ca. 1908–20
(P6-M)

and crafts. Such enterprises were largely outside the scope of central taxation and government control and could be engaged in by all segments of society. Landless laborers in urban or village settings, individuals or units within monasteries, landed peasants and aristocracy all could and did lend money, trade goods and practice crafts.

Depending on altitude and irrigation, such crops as barley, wheat, oats, peas, nuts and fruit were grown on farmland. The pastoral Tibetans raised yaks, yak-cow hybrids, goats and sheep, using the milk (and butter, yogurt and cheese), meat, fur and hides as products to be consumed or bartered. Nomad families had hereditary rights to certain pasturelands, usually a single low-altitude encampment for winter and several higher-altitude encampments for the warmer months. Each family or group of families would also have established relationships with certain estates, farmers or monasteries for the exchange of their products. Depending on location, some of these products such as wool, hides, butter and cheese would be carried by traders to the urban centers of Lhasa, Shigatse or Gyantse in central Tibet, or out to Ladakh, Nepal, northeastern India, China or Central Asia. These traders would return with European-manufactured goods and Mediterranean coral (via India), Central Asian gemstones and Chinese tea, silk, metal and luxury items. The presence of Italian, French, English, Russian and Japanese goods in the Museum's Tibetan collection give evidence of the scope of this trade.

Three interdependent systems of authority governed the lives of the Tibetan common man whether farmer, herder or trader: the central church-state embodied in the Dalai Lama; local monastic establishments, either part of the Gelugpa system or of semi-autonomous sects such as the Sakyapa or Kargyupa; and local secular rulers. The chapter on Tibetan history has given some indication of the relations between the Lhasa government and various local principalities and aristocratic families. The nobility derived their hereditary status through descent from one of the ancient kings or chiefs or by connection to one of the Dalai Lamas, whose families were raised to aristocratic status upon their recognition. Ennoblement could also be attained by performing some service to the government. The nobility derived their wealth from ownership of land, often at some distance from Lhasa, and their power from membership in the government. All noble families sent sons into the clergy where they could rise to positions of importance in the ecclesiastic hierarchy, and into the civil service where they similarly could become lay officials. Although they maintained houses in Lhasa to be close to the social and political life of the capital, most noble families spent considerable time managing their provincial estates. Lay or monk officials from the capital were also posted in outlying towns or monasteries. This small group of families thus had wide-ranging influence outside Lhasa.

In areas of Kham and Amdo where, in the twentieth century, Chinese civil authority overlaid Lhasa's religious authority, local rulers played one central power off against the other or asserted independence when the central powers were weak. In Batang and Derge, Kham, at the turn of the century, for instance, where each of the respective local hereditary headmen had strong ties to Lhasa through marriage to central Tibetan noble families, the headmen shared authority with the incarnate lama heads of the Batang and Derge monasteries which also had close ties to Lhasa through the church hierarchy. Despite these strong connections to

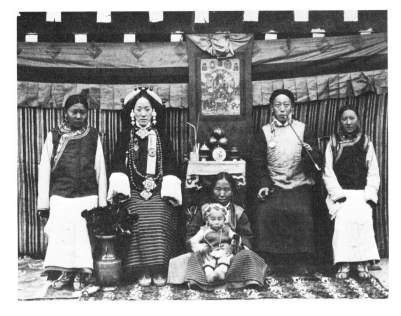

FIGURE 25

King of Derge with his family while
under house arrest in Batang, Kham.
Photo: Shelton, ca. 1913 (I49-S)

Lhasa, both Batang and Derge were subject to taxation and military occupation by Chinese (Sichuan) overlords.

A significant percentage of the population, perhaps as many as twenty percent of adult males, and a small fraction of females were removed from agricultural and pastoral activities and resided in the monasteries or convents. The primary goal of the monastic community was spiritual enlightenment and to this end it remained aloof from the rest of the population which supported the monastery's earthly needs. This independence was, however, tempered by the lay community's need for religious guidance. In addition, since families sent their sons (and infrequently, their daughters) into the clergy and usually continued to support them during their student years and beyond, and since the monasteries owned or controlled much of the land and economy of any given area, there was a constant practical interaction between the ecclesiastic and lay communities.

Women in Tibetan society had a degree of power and independence rare for Asia. Valued for their contribution within the economy of farming, herding and trading units, women moved freely in the community and were known for the same merry humor and love of travel as the men of Tibet. Marriage arrangements were primarily social contracts outside the formal concern of religion. Although monogamy predominated, polyandry was common and polygamy rare but not forbidden; separations and divorce were obtainable by either party to a marriage. Polyandry and polygamy were practiced to avoid divisions of estates and to ensure orderly succession from one generation to the next. The woman's role was thus central to domestic harmony and economic security. This was true for the farming and nomad classes as well as for the nobility. The great number of celebate monks and the practice of polyandry helped to keep the birth rate low. Tibetan society thus did not overburden the fragile environment in which it was nurtured.

Specific aspects of secular life will be discussed in connection with material in volume IV and volume V.

FIGURE 26

Tents set up for the annual summer outing of the Namgyal monks in Zara Linga, Lhasa. Photo: Cutting, 1937 (N22-C)

V. ARCHITECTURE

Tibetan architecture might best be placed under the title "enclosures," since tents as well as bricks and mortar formed an important element. Tibetan lifestyle was primarily sedentary and agricultural yet the mobility of all social classes of Tibetans was one of their chief characteristics. There is some dispute as to the origins of the *drokpa* (pastoral nomads) in Tibet, the one segment of society which was truly mobile, but there is no question that the penchant and necessity for travelling date back to the earliest records of Tibetan society. By the seventh century, Tibetans were known as valley dwellers with castles and fortresses and also as tent dwellers. This seeming contradiction can be explained by the necessity for Tibet's early rulers and nobles to have fortified strongholds in their respective valleys and also to be on marches outside these strongholds for part of the year to secure borders or conquer enemies. During these marches the tsenpo or leader and his court and soldiers lived in elaborate tents formally arranged to resemble a travelling palace. The tradition of such ceremonial tents persisted into the middle of the twentieth century in the festive appliquéd or painted rectangular tents used by church hierarchs and nobility while travelling, attending festivals, or when simply enjoying fair weather outings (figure 26). These colorful tents, decorated with auspicious and protective emblems, are quite different

from the rugged black yak hair tents of the true nomad (figure 27). The nomad tents had to withstand harsh climates and were constructed for durability and practicality rather than glorification and beauty. Both ceremonial and nomad tents, however, shared the necessity for ease of movement. They were sewn of easily dismantled sections so that the weight could be distributed among many pack animals. The household goods used in both types of tents, while reflecting the varied lifestyle of noble, cleric, or nomad, also shared the necessity of mobility: rugs for beds, collapsible tables and containers suitable for packing on animals. The material and structure of both forms of tents will be discussed in volume IV.

It was rather a small step from the domestic tent to the brick, mud and wood house of the common man (figure 29). Staggered one- and two-story structures arranged around open courtyards, typical of such

FIGURE 27

Nomad's tent, Tsang (Himalayan range to south in background). Photo: Cutting, 1935 or 37 (N7-C)

FIGURE 28

Houses in Sangen ("Badlands"), northwest of Batang, Kham. Photo: Shelton, ca. 1908–20 (M43-S)

homes, allowed the families to utilize the open spaces of court and flat roofs (note figure 24, a threshing scene taken on a rooftop in Kham). Courtyards sported an ad hoc arrangement of cloth awnings and ropes, a tent-derived system to accommodate the hourly fluctuation in wind and sunlight so typical of the Tibetan plateau. The loom, assortment of metal and wood utensils, strolling chicken, drying laundry, luggage and European-style chair in figure 29 are evidence of the multifaceted activities of such a household.

Even these humble examples of Tibetan architecture displayed the standard building material: solid exterior walls of stone, brick or pressed mud

built on stone foundations, finished with stucco or whitewash; packed earth floors; and wooden ceilings, doorways, doors, stairs, window frames, shutters, posts and brackets, decorated with polychrome opaque watercolors.

The necessities of climate and fortification resulted in a slightly different form of domestic architecture in remote and strife-torn areas such as the badlands of Kham (figure 28). Here farmers clustered tower-like houses together with cultivated fields nearby. Animals were kept in the lowest level during severe weather; their body warmth and excrement helped to heat the upper stories where the family lived and stored its grain. Several levels of flat roofs provided living and working space in fair weather. Limited access through doors or windows and systems of movable ladders and posts allowed the families to retreat inside the high-walled structures if attacked.

The fortress aspect of almost all Tibetan architecture can be seen at its most pronounced in the *dzongs* (castle/forts) of which Shigatse Dzong (figure 30), was a prime example. Like the earliest royal fortresses, Shigatse Dzong was built on a rock outcropping which increased its impregnability. The sloping walls, staggered system of rectilinear and curved surfaces, flat rooftops and ramp and stairway accesses beautifully suited the architecture to its natural rock setting, although these features were probably selected for strategic functions rather than aesthetic ones. As in the times of the ancient Tibetan kings, in the first half of the twentieth century such dzongs served as military and administrative headquarters, and as palaces of the rulers. In Shigatse this would have been the secular administrator for Tsang province.

The Potala, residence of the Dalai Lama, shows its affinity to dzongs such as Shigatse's more clearly when viewed from the back, or north side

FIGURE 29

Central open courtyard of house, southern Tibet. (Note loom at left, stair/ladder, miscellaneous household goods, women in Tsang headdress in background.) Photo: Cutting, 1920 (J20-C)

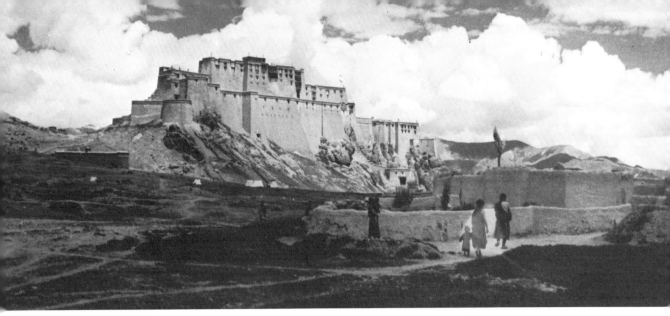

(figure 14 and cover), than from the front or south (figure 13). This magnificent palace, fortress and monastery is the most famous example of Tibetan architecture and epitomizes the multifaceted nature of the church-state which built it. It sits atop the "Red Hill," a natural rock escarpment rising in the center of the flat Lhasa river plain to the north-west of the town of Lhasa. This dramatic site had served as the location of a succession of fortresses and palaces from the seventh to seventeenth centuries, and also had an association with the Bodhisattva Ava-lokiteshvara from early times. When the 5th Dalai Lama decided to build the Potala here in 1645, the site already possessed both religious sanctity and strategic advantages. The present one-thousand room structure was basically completed in the great building program between 1645 and 1695. Only the tomb-chortens, crowned by gilt copper roofs, were added on as each Dalai Lama died. The most recent section is the 1935 tomb-chorten of the 13th Dalai Lama on the south facade. The Potala's red and white painted walls and golden roofs have dazzled visitors to Lhasa since the seventeenth century. The Chinese-style curved roofs were used in Tibetan temple architecture since the eighth-century building of Samye monàstery (see page 16). The gilt-copper workmanship of the Potala's roofs and ornaments is the product of imported Nepalese artisans, who also worked at many of the important monasteries in central and south-ern Tibet from the fifteenth to twentieth centuries.

Like the Potala, Sera monastery (figure 16), built in 1419 against the mountains northeast of Lhasa, demonstrated the incorporation of a religious building into a fortress structure. Indeed the Gelugpa church, as the state government, needed to assert administrative and protective aspects in its monasteries. Thus most of Tibet's monasteries occupied strategic and protected mountain sites. The massive walls and small high windows indigenous to Tibetan architecture also enhanced the practical indestructability and psychological dominance of these buildings. The tiered grouping of chapels, dormitories, houses, kitchens, shops, court-yards, and walls typical of all the large Tibetan monasteries can best be seen in Tashilhunpo (figure 11), founded in the fifteenth century and augmented over successive centuries to reach its maximum size, housing over three thousand monks in the first half of the twentieth century. An interior courtyard at Tashilhunpo (figure 12) and a chapel at Sera (figure

FIGURE 30

Shigatse Dzong, built by the Tsang king in 1635 (?) and the site of the 5th Dalai Lama's enthronement in 1642. Photo: Cutting, 1935 (M60-C)

FIGURE 31

13th Dalai Lama's summer palace,
Seshi Palber, Chansal Linga, Norbu
Linga, Lhasa. Photo: Cutting, 1935 or
37 (M18-C)

16) show the embellishments added to such prominent religious architecture: gilt copper roofs, standards, *chortens*, wheels and emblems (see *Symbols*, below); polychrome painted wooden trim for doors, windows, pillars and brackets; and polychrome painted or appliquéd cloth door and window curtains.

One type of purely religious architecture, the chorten (figures 9 and 10) retained its unique form even when incorporated into Tibetan building schemes. These chortens commonly served as reliquaries and sacred cult objects, to be circumambulated and venerated (figure 9). More rarely they were built as multistoried structures with usable interior chapels, as was the great chorten at Gyantse (figure 10). Built in the fifteenth century in southern Tibet, this chorten has obvious Nepalese influence in its gilt copper umbrella tower and painted eyes.

The summer palace of the 13th Dalai Lama (figure 31), set in the splendid gardens of the Norbu Linga outside Lhasa, is a unique combination of domestic and liturgical architecture. Its heavy, sloping stone walls and horizontal roof lines have been softened and lightened by large windows, colonnaded verandahs and bright cloth canopies. The religious sanctity of the inhabitant is conveyed by wall and roof ornaments similar to those of a temple. Brilliantly hued summer flowers, such as those found in the formal gardens surrounding the summer palace, were beloved by Tibetans, although their cultivation was limited to protected valleys.

The multifaceted nature of life in Tibet's villages and cities was reflected in an eclectic mix of architecture. In a 1930 view of Gyantse (figure 32), a chorten, market, apartment building, monastery (background, right) and dzong (far background, on hill) are all evident. A 1935 view of Lhasa (figure 33), shows a similar combination of domestic apartments, government offices and open-air market. Auspicious roof embellishments decorate the Lhasa apartment buildings, owned by aristocratic families, be-

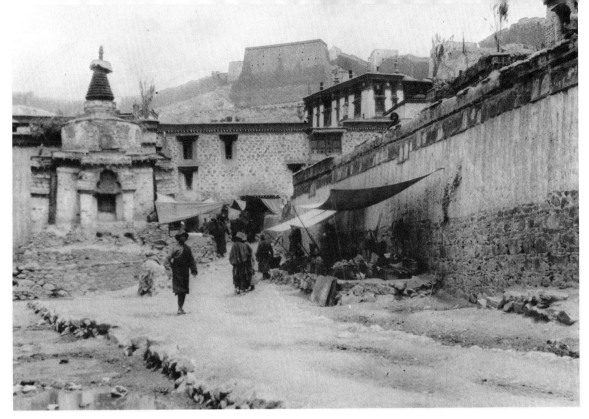

cause of their proximity to the Central Cathedral. Like medieval European cities, Tibetan towns grew over a period of centuries, organically clustering around a central structure, in the case of Lhasa around the seventh-century Cathedral, and in the case of Gyantse at the base of the dzong.

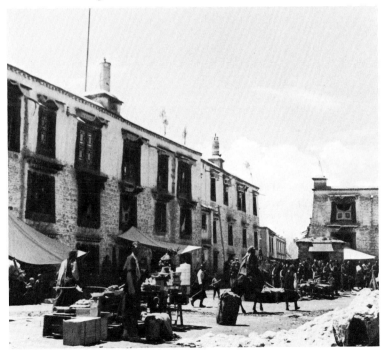

VI. THE FORMATION OF THE NEWARK MUSEUM TIBETAN COLLECTION

FIGURE 34

A ruined chapel at the monastery of Batang, Kham. Damaged main image of Padmasambhava (note that a small altar has been arranged at the center). Photo: Shelton, ca. 1908 (B8-S)

One of the special strengths of the Newark Museum Tibetan collection is that the majority of its objects were obtained directly from Tibet or from Tibetans, with documentation as to their original use and provenance. The bulk of the holdings was collected between 1905 and 1936 in the two areas of cultural Tibet then partially open to Westerners: Kham (eastern Tibet) and Amdo (northeastern Tibet). The collectors were American Christian missionaries working in these remote and strife-torn areas at a time when immense political and social upheaval was irrevocably altering traditional Tibetan life. It was perhaps the single space of time in the twentieth and preceding centuries when so many rare artifacts could have been willingly transferred to outsiders.

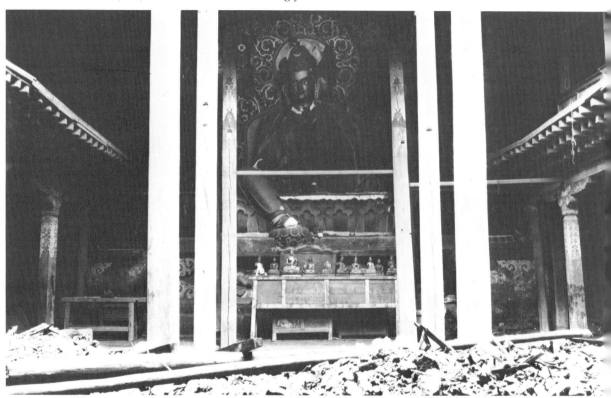

SHELTON

The first group of one hundred and fifty Tibetan objects came to the Newark Museum in early 1911. They had been collected by Dr. Albert L. Shelton, primarily in the town of Batang, situated just to the east of the then-existing Sino-Tibetan border, but well inside the Tibetan cultural sphere. Born in Indianapolis in 1875, Shelton decided as a young man on a career as a medical missionary. He obtained a medical degree and was sent to China in 1903 by the Foreign Christian Missionary Society, a branch of the Disciples of Christ. In 1904, Shelton, accompanied by his wife, arrived in Tachienlu, a town in the mountain wilds of Sichuan, western China. Although located within political China, Tachienlu was

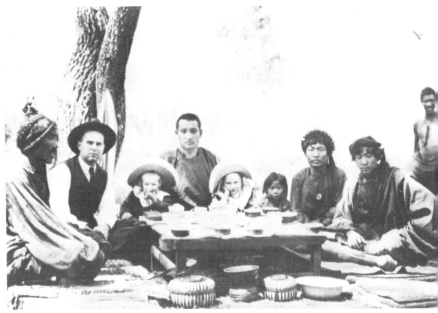

FIGURE 35

A Tibetan picnic, Jö Lama seated between Shelton daughters, Dr. Shelton at left, Batang, Kham. Photo: Shelton, ca. 1913 (171-S)

FIGURE 36

The Jö Lama and his wife posed for a formal photograph with some of their domestic possessions (note Italian cigar box) Batang, Kham. Photo: Shelton, ca. 1913 (157-S)

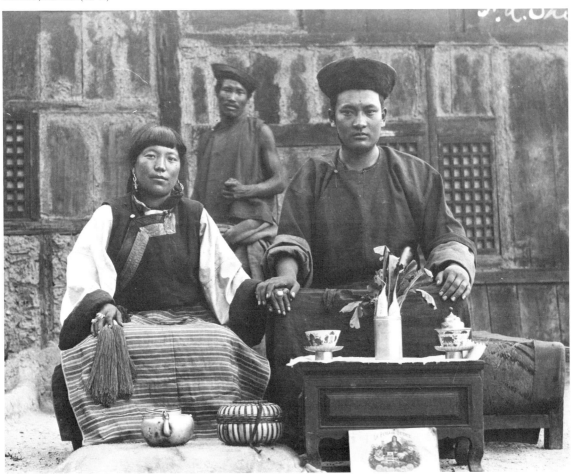

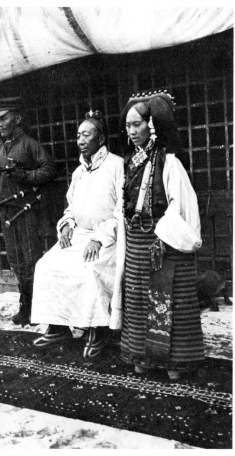

FIGURE 37

The Tibetan *Teji* (governor) of
Markham with his wife and piper
from his honor guard, Markham-
Gartok, Kham. Photo: MacLeod, 1919
(I60-M)

on the edge of the eastern Tibetan province of Kham. After four years
and the birth of two daughters, the Sheltons moved their mission hospi-
tal west to the more completely Tibetan city of Batang. In late 1910, the
Shelton family returned to America on sabbatical. During the return
journey, crossing the Pacific on a steamship, Dr. Shelton met Edward N.
Crane, a founding trustee of the Newark Museum. As their shipboard
friendship developed, Crane became interested in the group of Tibetan
artifacts (paintings, images, manuscripts, ritual objects and domestic
paraphernalia) which Dr. Shelton had collected and wished to sell in
order to finance the work of his mission hospital.

Circumstances of the most tragic nature made it possible for Dr. Shelton
to acquire this extraordinary collection. As discussed in the chapter on
history, territorial disputes between China and local Tibetan rulers had
resulted in severe consequences for Batang. In 1905 the Batang monas-
tery had been razed and most of its monks killed. The ruling family was
exiled to China where all, except one son, soon died. The Sheltons
arrived in Batang at a time when the entire frontier was suffering the
widespread destruction of its monastic system and the occupation of
Chao Er Feng's Sichuan troops.

In this turbulent period, Dr. Shelton's service to the sick and wounded
won him the friendship and gratitude of many rich and influential
Tibetans. Due to the destruction of the great monastery, quantities of
valuable books, paintings and ritualistic articles were endangered. Many
had been buried by the Tibetans during the years of fighting. Such sacred
objects had seldom if ever been permitted to pass into foreign hands.
Some were given to Dr. Shelton. Most were sold to him to obtain funds to
buy back land from the Chinese.

After the Sheltons arrived in the United States for their sabbatical in early
1911, it was decided, at Crane's behest, that their Tibetan objects would be
lent to the Newark Museum for display. It was Shelton's hope that they
would be eventually purchased by the Museum. Founded just two years
earlier, the fledgling institution in Newark was rather timid about pur-
chasing objects from such an esoteric location as Tibet. When the Shelton
items were put on view, however, the very exotic nature of the material
seems to have made the exhibition a great success: from February to
June, 1911, 17,724 people visited the display rooms. In the end, the matter
of purchase was settled when Crane suddenly died in the summer of
1911. In appreciation of Crane's interest in the collection, his wife and
brother purchased it from Shelton and presented the entire lot to the
Museum as a gift.

With the idea of adding to the original group, the Museum commis-
sioned Dr. Shelton to continue collecting Tibetan "curios" upon his
return to Batang in the fall of 1913. The political situation in China and
eastern Tibet had completely changed in the intervening years. The last
Manchu emperor had been overthrown in 1911, and Chao Er Feng ex-
ecuted. In the vacuum of central Chinese authority between 1911 and
1914, various provincial war lords struggled to control parts of Kham.
Shelton's letters from 1913 to 1918 refer to the precarious situation in the
border areas. Despite the "war conditions," robbers and local rebellions
mentioned in these letters, Shelton did manage to ship some items out to
Newark. The intricacies of sending freight from Tibet to America are
evident in a letter of June 25, 1913, to the Museum from Dr. Shelton,
outlining the route and expenses:

56

I'll give you as near I can the approximate cost, on 100 lbs. from Batang to New York.
Freight

460 miles on Yak (Batang to Tachienlu) about 8 Ru.	$2.00
140 miles on men's backs to Yachow at 40 Cash about	2.00
600 miles by water to Ichang at about 30 Cash	1.50
1000 miles by steamer to Shanghai at 75¢	.75
Shanghai to New York about	3.50
	$9.75

The friendship and respect earned by Dr. Shelton during his first stay in Batang were amplified in the 1913–19 period, as political events put Shelton in direct contact with the Tibetan central government. Lhasa had sent the Kalon Lama, Commander in Chief of the Tibetan army, to prevent Chinese troops from advancing beyond the 1914 border. The Governor of Markham, southwest of Batang, was also a direct representative from Lhasa. Dr. Shelton became a close friend of both men while assisting in the 1918 negotiations which temporarily settled the border questions between Tibet and China. Locally, the Shelton family became close to the two religious authorities in Batang, the Ba Lama, an incarnate who headed the re-established monastery, and Jö Rimpoche, an incarnate from neighboring Atuntse (Jö). The royal family of Derge was under

house arrest in Batang, and members of the King of Chala's family also resided there in exile from Tachienlu. The remaining son of the ruling family of Batang had returned from China and lived with the Shelton family.

In late 1919, the Sheltons again left Batang for the United States, taking with them a large group of objects for the Newark Museum. Rather than journey as before due east through Sichuan and down the Yangtse, they took a different route to the Chinese coast. Mules carried the boxes over the steep rocky trails south through Yunnan. The trails were slippery with melting snow and blocked by innumerable trees which had been felled in a criss-cross way to keep robbers from attacking suddenly and getting away quickly. The mules often fell and their loads had to be removed and carried forward by men. In the vicinity of Yunnan, twelve days out of Batang, the caravan was attacked by robbers. Dr. Shelton was taken captive and held for ransom; the rest of the party and most of the baggage escaped. Dr. Shelton was finally rescued in March, 1920, and returned with his family to the United States. The objects for the Museum, none the worse for the trip, arrived safely as well. Together with Shelton's extensive photograph collection, these two hundred fifty pieces were exhibited in 1920, supported by several publications.

After a recuperative stay in America, Dr. Shelton returned to Batang. This time he travelled alone, Mrs. Shelton having gone to India to work on some translations, their two daughters remaining in the States for schooling. Dr. Shelton intended to go on to Lhasa and establish a medical mission there. Through the Governor of Markham, he was able to obtain permission from the 13th Dalai Lama. Accompanied by Tibetan friends from Batang, Shelton started his journey to Lhasa on February 15, 1922. After one day out he received a note from the Governor of Markham asking him to turn back temporarily to Batang as the times were unfavorable for foreign visits to Tibet's interior. The next day, while heading back, Shelton was killed by bandits.[1]

The direct associations of the Shelton collection objects with Kham's royal families, clerics and important monasteries will be discussed in the appropriate sections of volumes II through V. Although the Shelton group established the Newark Museum collection at the outset as a comprehensive representation of the religious arts and secular culture of Tibet, it is especially noteworthy for its silver altar furnishings (volume II) and illuminated manuscripts (volume V).

The one hundred fifty Shelton objects given to the Newark Museum by the Crane family in 1911 are listed throughout the catalogue as "Crane collection." The rest of the Shelton collection, obtained between 1913 and 1920 directly from Dr. Shelton, and those pieces obtained from Mrs. Flora Beal Shelton, Mrs. Dorris Shelton Still and Mrs. Dorothy Shelton Thomas in subsequent years, are listed as "Shelton collection" with the appropriate year of acquisition.

EKVALL, HOLTON AND GRIEBENOW

Robert B. Ekvall, Carter D. Holton and M. G. Griebenow worked as missionaries in Amdo, northeastern Tibet, and adjacent Chinese areas of Gansu and Qinghai at various times between 1921 and 1949. They were

[1]Two other important personages in Kham died this same year: the Kalon Lama and the King of Chala.

FIGURE 39

Rev. M.G. Griebenow with two
Tibetan lamas, Labrang, Amdo.
Photo: Rev. Persons, 1949

FIGURE 40

Nomads of Amdo (note fine saddle
carpet set on white horse). Photo:
Griebenow, ca. 1920–30 (O22-G)

connected with the American-sponsored Christian Missionary Alliance.
It is interesting to note that the very existence of this Christian Mission-
ary group in northeastern Tibet was due to the good reputation of Dr.
Shelton's mission in Kham. Tibetans, and certainly the Lhasa govern-
ment, were not ordinarily well disposed to any Christian proselytizing
efforts. Like Kham to the south, Amdo suffered from the internal unrest
in China in the first half of the twentieth century. From 1724 to 1911, the
entire area had been administered by a Chinese amban located at Xining.
The amban oversaw the monasteries and the local rulers who had imme-
diate economic and legal control of the people. The nomads of Amdo,
however, were noted for their independence both from the central Chi-
nese authority and from local monastic or lay governments.

Between 1911 and 1950 the lowland areas of Amdo were subject to con-
flicts between the urban Chinese, the sedentary Tibetans and the Muslim
traders and farmers who formed a large segment of the population.
Muslim ascendancy was especially evident during periods when Chi-
nese central authority was weak, as during the Japanese occupation of
northern China from 1937 to 1945. The highlands of southern and west-
ern Amdo were unsuitable to agriculture and thus were left primarily to
the pastoral Tibetan nomads. Therefore during the first half of the twen-
tieth century, these Tibetans were able to preserve their independence
and remained relatively free of Chinese cultural influence.

The Museum's collections from Amdo are especially rich in nomadic
material. Ekvall, born on the Gansu-Tibetan border, obtained costumes
and objects of everyday life from Tibetan nomads in the Kokonor region.
This collection was purchased by the Museum in 1928. Ekvall's numerous
publications give much helpful information on social and political rela-
tions between Tibetans, Chinese and Muslims in this border area.

Carter D. Holton was stationed in various Chinese cities in Gansu but
made trips to Tibetan areas, primarily Labrang. It was in and around
Labrang that the extensive Holton collection, purchased by the Museum
in 1936, was obtained. These holdings are mainly secular artifacts record-
ing the lifestyle of nomadic and sedentary Tibetans, but several impor-
tant manuscripts and ritual objects are also included.

Rev. M. G. Griebenow was perhaps the most important American, from
the Tibetan point of view, to work in Amdo. Although the Museum
obtained only photographs from him, these provide vital documentation

of the in situ use of the Ekvall and Holton collections. Griebenow, known to the Tibetans as Sherab Danpel, and his family were stationed in Labrang from 1921 to 1949 (excepting furloughs). Griebenow performed medical services and, like Shelton, was fluent in Tibetan. He travelled extensively in the Tibetan highlands where he became well acquainted with local Tibetan secular and religious authorities. The two most important personages in Labrang, "Aba Alo" (Gen. Hwang Jen Ching) and his brother Jamyang Zhepa Rimpoche, were close friends of Griebenow. Griebenow made use of both his photographic and his medical skills to extend friendships in the Tibetan community.

The Museum's Amdo material has been recently enriched by the gift of color slides and black-and-white prints taken in 1949 in and around Labrang by younger members of the Christian Missionary Alliance: Dr. William D. Carlsen, Dr. Wayne Persons and Dr. Gene Evans.

SERVICE

The final American missionary collection acquired by the Museum is that of Robert Roy Service, who worked for the YMCA between 1905 and 1921 in Chengtu, the capital of Sichuan, due east of the Sino-Tibetan border highlands. The Service collection of secular artifacts was obtained either personally in the border area or from Chinese traders who travelled in those areas. The Museum purchased this collection from Mrs. Service in 1948.

CUTTING

The Newark Museum was fortunate to have had C. Suydam Cutting as a catalyst to its Tibetan activities from the 1930s through the 1970s. A New York financier with estates in New Jersey, Cutting was a naturalist-explorer with personal ties to the Theodore and Franklin Roosevelt

FIGURE 41

C. Suydam Cutting, on right, with Arthur S. Vernay having tea in a Tibetan house en route to Shigatse. Photo: Shelton, 1935 (I99-C)

FIGURE 42

Helen Cutting with Tibetan terrier on pony, central Tibet. Photo: Cutting, 1937 (197-C)

families. He travelled to the eastern borderlands of Tibet and to Ladakh and Turkestan with the sons of Theodore Roosevelt in the 1920s. Through his friendship with British Lt. Col. F. M. Bailey, Cutting obtained permission in 1930 to visit Gyantse and Khampa Dzong, towns in southern Tibet open to British trade. Probably using Bailey as an initial intermediary and his own credentials as an "American aristocrat," Cutting was able to establish a personal correspondence with the 13th Dalai Lama at least by 1931.[2] This correspondence, intended on the Dalai Lama's part as a way to reach the United States Congress and President and thus use American leverage to bypass British trade restrictions, and on Cutting's part to get permission for big game hunting in Tibet, lasted until the 13th Dalai Lama's death in 1933.

Contact continued, however, between Cutting and the Tibetan Assembly (the Kashag) and resulted two years later in an invitation for Cutting to visit Shigatse and Lhasa. In 1935, Cutting and his companion, Arthur Vernay, became the first Americans in the holy city. Because of their official passports, they were able to meet with church and government officials and to shoot hundreds of photographs of everyday as well as aristocratic and ecclesiastic life. Cutting and Vernay also obtained costumes and religious artifacts which are in the collection of the American Museum of Natural History, New York (as are the flora and fauna collected by the earlier Cutting-Roosevelt expeditions to the Tibetan borderlands). In 1937, Cutting returned to Lhasa with his wife, Helen. It was through his wife, a trustee of the Newark Museum from 1943 to 1961, and of course through a mutual interest in Tibet that Cutting became involved with the Newark Museum. When the Tibetan Trade Delegation visited the United States in 1948, Cutting arranged for them to spend a day at the Museum viewing some of the collection. This was the first direct contact between Newark and Tibet although Cutting had previously met the leader of the Delegation, Tsepon Shakabpa, in Lhasa. Depon Surkhang, second in command, had a long-standing connection with the Shelton family through his aunt who had married the headman of Batang. Cutting endowment funds have been used since 1950 to purchase objects for the Tibetan collection. Following Cutting's death in 1972, his widow

[2]The earliest extant letter now in the Newark Museum archive is dated July 19, 1931.

61

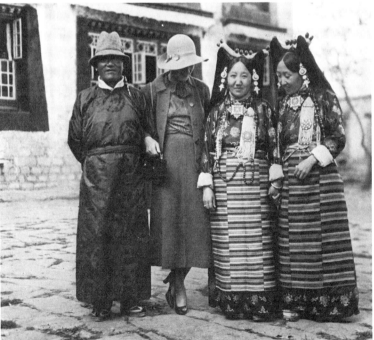

FIGURE 43

Helen Cutting with two monk officials, Lobsang Sanyes and Dumbog Simkhang, Dalai Lama's palace, Norbu Linga, Lhasa. Photo: Cutting, 1937 (I84-C)

FIGURE 44

Helen Cutting with Tsarong Dasang Dadul, Mrs. Tsarong and Mrs. Horkhang, Lhasa. Photo: Cutting, 1937 (I83-C)

FIGURE 45 (Left)

C. Suydam and Helen Cutting (with Lhasa Apso) viewing altar at the Newark Museum, April, 1949. Photo: The Newark Museum

FIGURE 46

Eleanor Olson and Edward M. Crane viewing the *Wheel of the Law* at the Newark Museum, April, 1949. Photo: The Newark Museum

FIGURE 47

Eleanor Olson and Alice B. Kendall, Director of the Newark Museum, holding a Tibetan manuscript page with Tsephal Taikhang of the Tibetan Trade Delegation looking on, Newark Museum garden, September, 1948. Photo: The Newark Museum

Mary Pyne Filley Cutting (Helen, his first wife, died in 1961) gave his collection of correspondence with the 13th and 14th Dalai Lamas, the Kashag and Tsarong Shapé, photographs, films, and miscellaneous memorabilia to the Newark Museum. Mrs. Cutting's great generosity to the Museum has continued to make the Cutting archives a rich source of Tibetan documentation.

DANA AND OLSON

The formation of the Newark Museum's Tibetan collection would not have been possible without the energy and enthusiasm of certain individuals within the institution. John Cotton Dana, founder and first director, had a personal love of Oriental cultures and arranged for the creation of the Museum in 1909 with the purchase, by the City of Newark, of a private Japanese collection. Dana thus set the stage for an easy reception, two years later, of the Shelton loan exhibition as arranged by Crane. Once on the Tibetan "trail," Dana applied his characteristic energy and found funds to commission Shelton to add to the Museum's holdings. The rest of the Shelton material and the Ekvall collection were purchased during Dana's tenure. The three subsequent directors of the Newark Museum have continued with equal fervor to support the enrichment of its Tibetan holdings.

The most important individual to shape the direction of the Tibetan collection was Eleanor Olson, in charge of the Oriental collections from 1938 to 1970. Although Miss Olson was not designated curator until such departments were established at the Museum in 1950, she had specialized in Asia and particularly in Tibet as an assistant to the Registrar. Her initial two volumes of the Tibet catalog (I and II) were issued in 1950. Miss Olson was able to visit Tibetan areas of the Indian and Nepalese Himalayas during a tour of Asia as a Fulbright Scholar in 1956. Volume IV of the Tibetan catalogue was completed by Olson in 1961, and volumes III and V, published in the year of her retirement, 1970, capped her long and distinguished career.

Eleanor Olson's pioneering research in the Tibetan field was done at a

FIGURE 48

Members of the Tibetan Trade
Delegation in the Newark Museum
garden, September, 1948. Left to right:
Tsepon Shakabpa, Depon Surkhang,
Pangdatshang and Tsephal Taikhang.
Man at right is Nepalese interpreter.
Photo: Cutting (I25)

time when such studies were in their infancy. Until the arrival of the 1948
Tibetan Trade Delegation to America, there were no Tibetans in the
United States and only a handful of Tibetologists. Among these, Miss
Olson was lucky to have the assistance of such individuals as Roderick A.
MacLeod (Shelton's associate in Batang), Wesley E. Needham, advisor to
the Tibetan collections, Beinecke Rare Book and Manuscript Library, Yale
University, and Schuyler V. R. Cammann, whose wide-ranging knowl-
edge of Tibet, China and Central Asia was especially helpful.

FIGURE 49

Samuel C. Miller, Director of the
Newark Museum and Valrae
Reynolds, Curator of Oriental
Collections, greeting His Holiness,
the 14th Dalai Lama, with Tibetan
scarves on his arrival at the Newark
Museum, July 27, 1981.
Photo: Stephen C. Germany.

FIGURE 50

His Holiness, the 14th Dalai Lama, next to the *Wheel of the Law*, the Newark Museum, July, 1981. Photo: Stephen C. Germany.

The political events of the third quarter of the twentieth century and the exodus of Tibetans from their homeland have brought Tibetan artifacts into the commercial market in quantities unknown before 1959. Through gifts and purchases during the last twenty-three years, the Museum has been able to enrich its holdings of central and western Tibetan pieces. The scholarly assistance of Tibetan refugees in the New York-New Jersey area has allowed the Museum to greatly strengthen its research on the collection. Those who have helped particularly are Nima Dorje, Lobsang Lhalungpa, Mr. and Mrs. Lobsang Samden, Tsephal Taikhang, Tenzin Tethong, Mr. and Mrs. Phintso Thonden and Dorje Yuthok. On his several trips to the United States, Tsepon W. D. Shakabpa, leader of the 1948 Trade Delegation, has helped to catalogue the archive photographs and manuscripts.

The Newark Museum has had the great honor of receiving visits from His Holiness the 14th Dalai Lama on two occasions. In October, 1979, he delivered a major address on "Deity Yoga," and in July, 1981, he toured the exhibition, *Tibet, A Lost World*, and presented a charm box to the collection. His Holiness has thus given his blessing to this large and active collection which shows the rich heritage of the Tibetan people.

VII. SYMBOLS IN TIBETAN ART

The drawings and explanations included in this section are for symbols found generally in the decoration of Tibetan architecture, ritual objects, domestic paraphernalia and personal attire. Attributes, body positions, gestures and insignia specifically connected with deities and saints will be discussed in volume III, as these occur primarily in painting and sculpture. Most Tibetan symbols have profound and complex meanings; the simplest and most generally accepted explanations for each example have been given here, in the interests of clarity.

Note: Tibetan (T.), Sanskrit (S.) and Chinese (C.) words for each symbol are given in parentheses when appropriate.

1. *Symbols as Substitutes for Aspects of Buddhahood*

A. THE WHEEL and THE WHEEL OF THE LAW
(T. *korlo* and *cokhor*; S. *cakra* and *dharmacakra*)

The wheel was chosen in early Indian Buddhist iconography to represent Sakyamuni's First Sermon, in the Deer Park at Sarnath. The act of preaching is called "turning the wheel of the law" (S. *dkarmacakra*), incorporating an ancient Indian emblem for the world-ruler (S. *cakravartin*; "he who sets the world in motion"). In early Buddhist art, the wheel is one of several symbols signifying the great events of Sakyamuni's life and is shown as six-spoked, often on an empty throne and surrounded by worshipping gods, men and animals. The wheel was also depicted in early Indian art surmounting a column, a pre-Buddhist emblem with cosmological and imperial associations. The wheel as a radiating disk is also interrelated with the solar disk and its world-controlling revolutions.

As Buddhism developed and spread across Asia, the wheel came to symbolize the Buddhist doctrine. In Tibet the wheel is frequently encountered as an architectural ornament, as a separate emblem, and as part of various sets of ornaments. The Tibetan wheel of the law commonly has eight spokes or a multiple of eight and is set in a lotus base with a halo of flames to indicate its sacred character. The *whirling emblem* (see below) is often set at the center. Although not shown with a column, the Tibetan wheel retains its significance as an emblem of sovereignty and is thus associated with the empowerment of important lamas such as the Dalai Lama.

As an architectural ornament, the wheel of the law is almost always shown in Tibet flanked by two deer-like animals. The common worshipping animals in early Indian iconography are gazelles, recalling Sakyamuni's sermon in the Deer Park. In Tibet these animals (T. *seru*), one of which has a single horn in the center of its head, are described as unicorns or as rhinoceroses, which symbolize renunciation and solitude.

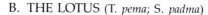

B. THE LOTUS (T. *pema*; S. *padma*)

This singular water plant was associated with divinity throughout the ancient world. The Egyptians, Assyrians, Greeks and Persians all ascribed sacred qualities to the white or blue flower which grows undefiled out of its muddy water base. The early Buddhists adopted the lotus symbolism already existing in India, connecting the flower's purity and perfection with divine birth and the emancipation of Buddhahood. As Mahayana Buddhism developed and anthropomorphic representations of the Buddhas began to appear in India and elsewhere in Buddhist Asia after the second century A.D., lotus flowers in conventionalized disk-form were shown sprouting from the feet of Buddhist images or, in naturalistic or stylized form, supporting seated or standing images of saints and divinities. The lotus throne or support was a concrete symbol of the attainment of enlightenment. The Mahayanist doctrines of Buddhist paradises with their lotus pond settings (as in the *Lotus Sutra*) reinforced the lotus symbolism. The lotus has a further Mahayanist meaning as the female element, paired with the male element *vajra* (see below).

In Tibet, the lotus is commonly seen in three ways: 1) As a naturalistic, growing plant, it is shown with leaves and stem. It can be seen this way on its own, as a decorative element, in lotus ponds in paradise scenes, and held in the hands of deities and saints. 2) As a conventionalized radiating disk, it is depicted in decorative schemes and in sets of emblems. This form of the lotus flower is interconnected with the form and meaning of the sun disk and the wheel of the law. 3) The petals of the flower are used to form supports for divine images and sacred emblems. In this form the petals are depicted growing upward, downward, and, in "double-lotus" pedestals, in both directions. Such lotus bases occur in both realistic and abstract forms but always retain the symbolism of purity and the transcendent state of enlightenment.

C. THE CHORTEN (S. *stupa* and *dhatu garbha*)

Perhaps the single most potent symbol of Buddhism, the *chorten* is analogous to the Christian cross. Like the cross, the chorten has specific associations with death and triumph over death. According to legend, Sakyamuni's remains were divided up and enshrined in thousands of tumulae or reliquary mounds. These *stupa* (mounds) or *dhatu garbha* (relic preservers) were an ancient funerary tradition for rulers and saints in India. When adopted by Buddhism, the stupa came to symbolize the departed lord and the ultimate state of nirvana into which he had passed. By the third century B.C., Buddhist sites throughout India and adjacent areas had stupas as their main cult objects. The donation of stupas by both monks and laymen was an important element in Buddhist religious life.

Stupas, both as actual buildings of earth, stone and brick, and as relic containers of gold, silver, copper, crystal, stone or wood, spread throughout Buddhist Asia, enshrining the remains of saints, marking sacred sites, and serving as devotional objects on altars. The stupa always retains its essential form: a dome or bell-shaped base (S. *anda*; "egg"), surmounted by a vertical column or tower of stepped form (S. *harmika*; "sanctuary above earth beyond death and rebirth") and a crowning canopy, or umbrella, signifying royalty.

Both the architectural and the reliquary form were immensely popular in Tibet and, until recently, were found throughout the countryside and in all towns and villages. Except for a few massive examples, such as the Palkhor Choide in Gyantse (see figure 10), which are actually buildings with functioning interiors, these stupas or *chortens* ("receptacles for offerings") were enclosed shrines inside of which bodily remains and ritual offerings were consecrated. The exterior chortens were to be circumambulated clock-wise, and small portable chortens were an important element on altars.

In Tibet the five basic components of the chorten came to be regarded as symbolic of the aspects of enlightenment in the same way the mandala (below) does. For instance, the five elements and the five mystic Buddhas are represented by the five basic components: the base, earth; the dome, water; the thirteen tapering steps, fire; the moon and sun finial, air; the surmounting flame, ether. The thirteen tapering steps also symbolize the thirteen grounds of enlightenment.

D. MANDALA (T. *kyil-kor*)

The recurring use of the circle in Buddhism has already been seen in the wheel and lotus, above. The perfect nature of the circle came in later Buddhist doctrine to be embodied in the *mandala* or mystic circle. Although many types of geometric diagrams both in two-dimensions (as in painted mandalas and colored sand mandalas) and three-dimensions (as in offering mandalas and architecture) are considered mandalas, the most common form is the two-dimensional complex of circles and squares, representing a sacred enclosure and related to the concept of chorten as a container of sacred power.

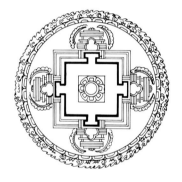

Tantric Buddhism in Tibet made use of such mandalas as meditational tools. The basic form, as shown in the diagram here, involves an outer circular border of flames and an inner border of lotus petals. The inner sanctuary is a "divine mansion," shown as a square with four symmetrical gateways. The walls and gateways are often shown decorated, similar to those of a Tibetan temple. The arching prongs over each gateway are the tips of the underlying crossed *vajras*, below. Each form and color of the mandala symbolizes attributes and qualities that constitute a state of enlightenment. Inside the walls of the castle is the innermost realm of divine power.

E. VAJRA (T. *dor-je*)

This "thunderbolt" emblem first appeared in Indian Buddhism as the symbol of Vajrapani ("thunderbolt-in-hand"), the special protector of Sakyamuni, a direct borrowing of the trident weapon of the Vedic god Indra. In later Buddhism, Vajrapani became the chief deity of the powerful beings converted to Buddhism. The *vajra* thus symbolizes indestructibility and overwhelming power. The Tibetan word *dorje* can also be translated "diamond" or "sovereign of stones." Thus vajra/dorje is expressive of the adamantine ("diamond-hard") quality of Buddha-mind. The vajra is seen in Tibetan art as the attribute of several deities who either hold it in one of their hands or have it placed near or on their body. The vajra is also used as an element in religious architecture and decoration, both in the single and crossed forms. This symbol furthermore occurs in Tibet as a tool for ritual use. As such it is always paired with the

bell (T. *dil-bu*; S. *ghanta*). The bell must match the vajra in size and have as its handle a half-vajra of similar form (see volume II for examples of vajra and bell pairs).

Mahayanist doctrine developed a scheme of pairing the vajra symbol which is conceived of as "means" and masculine, with the lotus symbol, conceived of as "wisdom" and female. The union of vajra and lotus symbolizes the supreme truth. In Tibet the bell replaces the lotus as the female emblem of wisdom and is manipulated together with the vajra in rituals.

Tibetan dorjes appear commonly with five prongs at each end (four outer prongs curving over the central fifth). Dorjes with nine prongs are used for certain tantric practices. The crossed dorje form has special significance as the emblem of equilibrium, the cross forming the foundation of the world. For initiates, the crossed dorje with its four parts in different colors symbolizes the four types of Buddha activities; each is believed to be capable of bringing about in a meditator the necessary inner purification, development, expansion of influence or elimination of negativities.

F. MANTRAS (symbolic sounds)

Sound is an important aspect of the spiritual world in Asia. Chants and spoken prayers are essential elements of all worship, invoking aspects of the sacred realm of pure sound. Such aural devices can be seen as well, and their presence should be assumed when viewing mandalas and other meditative tools. For example, "seed-syllables" (S. *bija*) for specific Buddhas can take the place of representations of the deity in mandalas and other paintings or cult objects. Two often-encountered *mantras* in Tibetan art are:

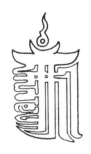

ALL-POWERFUL TEN (T. *namchu wangden*; S. *dasakara vasi*)

This is a mystic monogram composed of ten Sanskrit syllables, *Om Ham Ksha Ma La Va Ra Ya Hum Phat*, surmounted by the sun/moon/flame symbol as in the chorten, above. The ten syllables represent the elements of the cosmos as put forth in the Kalachakra doctrines (section 4, below).

MANI

The most popular mantra in Tibet is *Om mani padme hum* ("Oh, glorious jewel in the lotus protect [me]") associated with Avalokiteshvara. This mantra is not only chanted but is also inscribed on stones in either Sanskrit or Tibetan letters. The stones are then placed in walls or piles at auspicious spots (see figure 19 and volume II).

2. *Sets of Symbols*

A. EIGHT GLORIOUS BUDDHIST EMBLEMS
(T. *tashi takgye*; S. *ashta-mangala*)

The eight emblems — umbrella, fish, conch, lotus, wheel, banner, vase and endless knot — are the most common decorative elements in Tibetan life as seen in costumes, tents, architecture and in much of the paraphernalia of everyday life. Two emblems in the set have quite early origins in Indian Buddhism and have been discussed above as independent symbols: *The Wheel of the Law* and the *Lotus*. The other six have less profound symbolism but are still found as independent emblems:

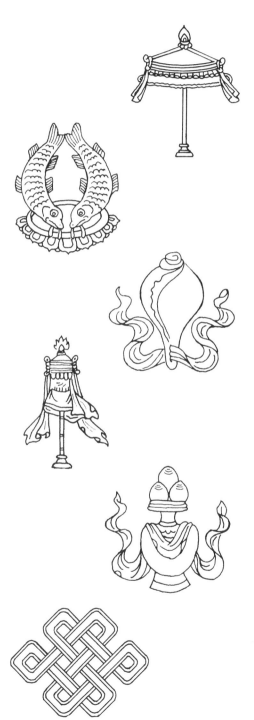

THE UMBRELLA (T. *duk*; S. *chatra*)

The early royal connotations of the umbrella in India were incorporated into Buddhist lore signifying the Buddha as universal spiritual monarch. When used in the set of eight, the umbrella is depicted realistically, with decorative streamers, ruffles and a flaming finial.

THE GOLDEN FISH (T. *ser-nya*; S. *matsya*)

The twin fish, shown with adorsed arching bodies, are symbolic of freedom from restraint (i.e. in the fully emancipated Buddha state, no obstacles to freedom are encountered). The fish also connote the life-giving properties of water.

THE CONCH SHELL (T. *dung*; S. *sankha*)

The conch is symbolic of the spoken word, a tradition originating in Vedic India. The shells were valuable and rare items in Tibet, imported from India for ritual use, both as musical instruments and as offering vessels (see volume II). Shells with whorls turning to the right, recalling the "blessedness of turning to the right" as Buddhists do in circumambulating sacred monuments, were especially prized.

THE STANDARD OF VICTORY (T. *gyaltsen*; S. *dhvaja*)

The standard is taken from the banner of victory of military battles and symbolizes the attainment of enlightenment. Like the umbrella (with which it can be confused), the standard is depicted realistically, with billowing streamers, ruffles and flaming jewel finial. Because it is believed effective in combating the powers of evil, the standard is often found as roof and gateway decoration, fabricated out of gilt copper, painted wood or cloth (see figure 16).

THE VASE (T. *bum-pa*; S. *kulasa* or *dhana kumbha*)

The vase is symbolic of longevity when it contains life-giving water. As the container of treasures it symbolizes the fulfillment of highest aspirations. The vase also recalls reliquary containers. See volume II for the use of actual vases in rituals.

ENDLESS KNOT (T. *palgyi be'u*; S. *shri vatsa*)

This emblem symbolizes the interrelatedness of all things and the endless interaction between wisdom and compassion. It can also be interpreted as a symbol of longevity or the "knot of life."

B. THE SEVEN TREASURES OF ROYALTY

(T. *gyalsi nadun*; S. *sapta ratna rajya*)

These ancient Indian treasures of royalty — the Wheel, Jewel, Horse, Elephant, Queen, General, Minister — were adapted as the special treasures of the Buddha in his role as Universal Spiritual Monarch. The treasures are shown as offerings to deities in various groupings, especially in paintings (see volume III).

The Wheel, discussed above, can stand as a separate emblem. The wish-granting jewel and the horse also appear as independent emblems in Tibetan art and ethnography.

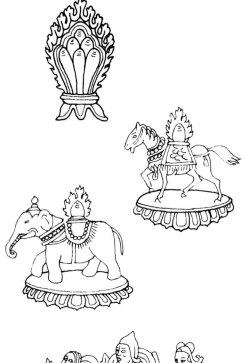

THE WISH-GRANTING JEWEL (T. *yizhin norbu*; S. *cintamani*)

The mother of all gems is usually depicted in Tibetan Buddhist art as a bouquet of six or nine elongated jewels surrounded by flames. The belief in the magical efficacy of this fabulous gem goes back to ancient times.

THE HORSE (T. *tamchog*; S. *āsva*)

Since he carries his rider pegasus-like through the air in whatever direction desired, the jewel horse is associated with the idea of the realization of material wishes. On his back is a single flaming jewel or *The Three Jewels* (see below). The same horse appears on the prayer flags where he is known as the *lung rta* or "wind horse."

THE ELEPHANT (T. *langpoche*; S. *hasti*)

Taken from Indian mythology, the elephant is the mount of kings and symbol of royal splendor. Like the horse, the elephant carries the flaming jewel on his back.

The queen, general and minister can either be shown together, as here, or separately.

THE QUEEN (T. *tsunmo*; S. *rani*)

Symbolizes constancy and royalty.

THE GENERAL (T. *magpon*; S. *kshatri*)

Conquers all enemies.

THE MINISTER (T. *lonpo*; S. *mahajana*)

Regulates the business of empire.

C. PRECIOUS JEWELS

(T. *rinchen dun*, "seven precious jewels," and *newai rinchen dun*, "seven semi-precious jewels;" C. *ba bao*, "eight jewels")

Like the treasures of royalty, the jewels of wealth are frequently depicted as offerings in paintings and as auspicious emblems in textiles, architectural decoration and domestic implements. These groups, which seem to follow closely the various sets of eight treasures known in Chinese mythology, occur in Tibet in sets of seven. Shown are the most common.

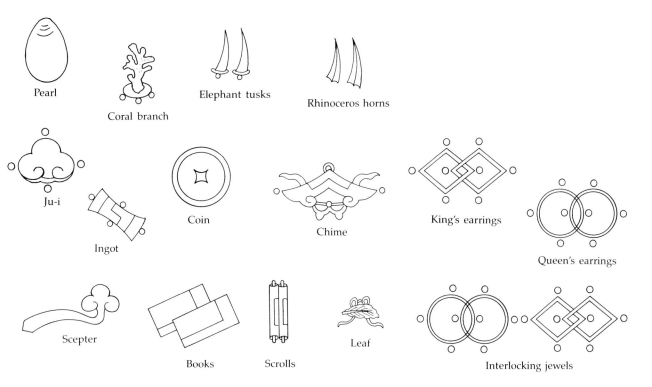

D. OFFERINGS OF THE FIVE SENSES

(T. *doyong nga*; S. *panca kamaguna*)

Often shown in a bowl, as here, these are:

Mirror (sight)
Cymbals or lute (sound)
Incense in conch shell (smell)
Vessel containing food such as fruit (taste)
Cloth such as silk (touch)

The offerings can also be spread out as individual items.

3. *Individual Symbols*

A. SUN-MOON EMBLEM (T. *nyi-da*)

The symbolism of this emblem is discussed above under *chorten*. It can occur as an independent celestial emblem.

B. THE THREE JEWELS (T. *konchog-sum*; S. *tri-ratna*)

This is the Buddhist symbol of the Holy Triad (S. *Buddha, Dharma, Sangha*) in which every professing Buddhist takes his daily "refuge." Dharma signifies the Word of Buddha or the Law. Sangha, originally signifying Buddha's order of monks, is generally interpreted by Tibetans as meaning the Congregation of Lamas or the Buddhist Church.

C. SWASTIKA (T. *yüng-drung*; S. *svastika*)

The swastika is one of the most ancient and widely diffused symbols, present in prehistoric Asia, Eurasia and the Americas. Tibetan Buddhists regard it as a symbol of the eternal state of enlightenment (*bodhi*). It is also used as an auspicious emblem for longevity. Among the Bon it is a most important emblem, taking the place of the Buddhist crossed dorjes and symbolizing the foundation of the world. The arms of the Buddhist swastika characteristically point to the right or in the direction of the sun's course. Those of the Bon swastika characteristically point in the opposite direction. However, the Buddhists often use a pair of swastikas with arms pointing in opposite directions. The swastika is considered a great luck-bringer, frequently appearing on the door of Tibetan houses.

D. WHIRLING EMBLEM (T. *gakhil*)

This circle enclosing three (sometimes four) "whirling" segments signifies the blissful mind radiating compassion. Alternately it can represent ceaseless change and movement like the swastika. Three segmented circles also occur in Chinese mythology.

E. PEACOCK FEATHER

This auspicious feather with an "eye" at its tip is the special symbol of certain deities and saints. Peacock feathers are placed in vases containing the Water of Life (see volume II). According to legend the peacock can swallow poisons without being harmed; therefore its plumage is used to symbolize the eradication of spiritual poisons.

F. YIN-YANG

This is an ancient Chinese symbol of the two First Causes or Creative Principles *Yang* and *Yin*, expressed in opposites such as heaven and earth, light and darkness, male and female, movement and repose, etc. The emblem is frequently seen on Tibetan objects; for instance it forms the center of the crossed dorje emblem described above.

4. *Astrological and Divination Symbols*

A. THE TWELVE ANIMALS

The *twelve animals* designate hours, days, months, years and points of the compass. They are the mouse, ox, tiger, rabbit, dragon, serpent, horse, sheep, monkey, cock, dog and boar.

The *five elements* which link to the twelve animals to form sixty possible combinations in the calendar year are water, fire, metal, wood and earth.

The Tibetan calendar is based on a complex system derived from ancient Chinese, Indian and perhaps western Asian concepts. The use of twelve animals and various groups of elements as astrological symbols was probably well established in Tibet when Atisha introduced the cycle of sixty years in 1027 A.D. Under this system, based philosophically on the *Kalachakra Tantra*, the twelve animals combine with five elements to designate sixty years. Since the names are repeated every sixty years it is impossible to determine exact dates in Tibet unless the cycle is known or the animal-element designation is linked to the name of an historical individual or event.

B. TRI-GRAMS (T. *jung-kham*; C. *pa-kua*)

These ancient Chinese tri-grams are attributed to a legendary emperor named Fu-Hsi. The three unbroken lines symbolize the active male principle, *Yang*, of which the most complete expression is heaven. The three broken lines symbolize the female, passive principle, *Yin*, expressed by earth. The combinations of broken and unbroken lines symbolize essential elements in the universe in which Yang and Yin are variously combined: sky, lake, fire, thunder, wind, river, mountain and earth. The Tibetans use these tri-grams in astrology and divination.

5. *Mythological Animals*

A. MONSTER MASK

 (T. *chibar*, "that which resembles nothing," and *shi-dong*, "face of splendor;" S. *kirtimukha*, "glory face;" C. *t'ao t'ieh*)

This disembodied face represents a god of the skies. The mouth is shown devouring or giving forth snakes, dragons, sprays of vegetation, clouds or other substances, showing perhaps that like the sun the god of the skies has the dual function of creator and destroyer. The *chibar* is characteristically shown in conjunction with two other creatures: his human arms hold the tails of snakes or dragons, or he is flanked by dragons, sun-birds or other animals. The mask can appear armless as well. Both forms of the mask lack a lower jaw: the face is a composite monster using elements of ferocious beasts such as the lion. The sky bird *garuda*, discussed below, is interlinked in meaning and depiction with the monster mask. The masks, often connected by festooned pearls, frequently occur as decoration on Buddhist altars and on such ritual objects as bells (for both, see volume II). The masks are popularly regarded as auspicious emblems to protect the devotee and ward off evil. On a higher level the grip of chibar's jaw symbolizes the unfailing compassion of the enlightened, which firmly holds sentient beings.

B. MAKARA (T. *chusin*; S. *makara*)

This Indian mythological sea monster symbolizes the life-giving power of water. Like *nagas* (see below), the *makara* is a keeper of treasure. Pairs of makaras appear on the sides of aureoles which surround deities (see volume III). Pearls, flames and treasures can issue forth from their mouths. The single makara is often used to form the spout of vessels (see volumes II and V) or as an architectural finial. In the latter function, the makara is popularly regarded as an auspicious emblem to ward off evil.

C. NAGA (T. *lu*, "serpent;" S. *naga, nagini*)

The nagas are serpent demigods in Indian mythology but they also figure in Tibetan folklore, probably predating Indian influence. Serpent demigods appear in Bon cosmology in which they rank in the lowest quadrant of the universe. The cult of nagas was widespread throughout Buddhist Tibet since they are believed to enhance the fortune of devotees and send rains for crops and pastures, but will also send diseases called *lu-ne* if displeased by humans.

D. DRAGON (T. *druk*; C. *long*)

Although it interrelates somewhat in Tibetan mythology with the Indian idea of the *naga* water monster, the Tibetan concept of dragon is primarily based on the Chinese model. In ancient China, the dragon symbolized renewal and transformation with special power over rain and association with the season of spring. The *long* dragon, the commonest form in Chinese and Tibetan art, is the most powerful and inhabits the sky. According to Chinese mythology, the long should have the head of a camel, horns of a deer, eyes of a rabbit, ears of a cow, neck of a snake, belly of a frog, scales of a carp, claws of a hawk and palms of a tiger, thus incorporating the many powers and talents of the animal world. The fully developed Chinese dragon which was transmitted in textiles, ceramics and other decorative arts to Tibet is often shown chasing or clutching a flaming jewel or disc. The dragon also had the special association in China with the emperor, and the importance of this would have varied, for Tibetans, with their proximity and degree of subordination to the Chinese empire. A very stylized dragon or pair of dragons is encountered in Tibetan art, with the body or bodies dissolved into cloud-like forms.

E. GARUDA (T. *khyung*; S. *garuda*)

The *garuda* is a mythological bird of Indian and Tibetan folklore. He wages continual warfare against the nagas or serpents. Thus he is considered to be a protection against poisoned water and other maladies sent by the nagas when they are angered. The nagas also bless mankind by sending rain, and so the garuda, due to his power over them, is looked upon as a rain bringer.

The garuda is part bird and part human. His human arms hold a serpent which he chews. Frequently he treads upon serpent gods. The traditional antagonism between serpents and bird-man beings or eagles seems to have come from the West, where, for example, it was characteristic of ancient Mesopotamia and Greece. In western tradition, how-

ever, a spiritual opposition is commonly stressed, the bird representing the higher spiritual principle released from the bondage of matter. In Indian symbolism the opposition was strictly that of natural elements, the "fair-feathered," golden-winged garuda symbolizing the sun and the serpents symbolizing the energy of the earthly waters. In Tibet the garuda appears to have lost its association with the sun and to have become a more comprehensive sky god. Garuda is one of the four animals in Bon mythology.

F. KINNARA (T. *mihamchi*; S. *kinnara, kinnari*)

These heavenly musicians of Indian origin are represented as half human and half bird. They have an angelic role as peripheral creatures of auspicious nature and do not possess the importance of the garuda.

G. PHOENIX (T. *gyaja*; C. *feng huang*)

The Tibetans use the Chinese phoenix as a general auspicious emblem but do not give it the special significance which it has in Chinese mythology as the emblem of the Empress and the harbinger of peace and prosperity.

H. LION (T. *senge*; S. *sinha*)

The lion has an indigenous history as a mystic animal in Tibet, which was reinforced when Buddhism was introduced with its use of a lion throne for the Buddha. The lion can be seen in many roles in Tibetan art. It is the third of the Bon mythological animals. The lion of Buddha remains as a peripheral supporting beast for the thrones or bases of various deities, often literally supporting the base with its up-raised hands in an Atlas-like pose. There is also a rather separate concept of the snow lion as an emblem of the Tibetan state. As such it appears on the Tibetan national flag where it stands for the fearlessness and superiority of the religious law which the Dalai Lama upholds.

I. TIGER (T. *tak*; S. *byāghra*)

The tiger is the fourth Bon mythological animal. As in China, the tiger symbolizes in Tibet the king of wild beasts, possessing special dignity and courage. See below for the special meaning of the tiger when shown as a flayed skin.

J. MONGOOSE (T. *ne-le*; S. *nakula*)

The mongoose symbolizes wealth since, according to Indian tradition, he conquers the serpent demigods or nagas who guard the treasures hidden beneath the earthly waters. He is shown disgorging jewels.

K. FLAYED SKINS (T. *pag*)

The flayed skins of various wild animals can be seen as the covering of deities' thrones or seats, as attributes of deities, and as offerings to deities. The animals chosen for this role are most commonly tigers, elephants and antelope, but all manner of beasts including humans can be used in this way. The basic meaning of the flayed skins is the power of Buddhism and its skilled practitioners to subdue the wild forces of nature. These wild forces can be interpreted as our own inner psyche or as external evils.

Bat

Shou

Mountain/sea

Clouds

Peony

Chrysanthemum

The three fruits

6. *Miscellaneous design elements derived from Chinese mythology*

The symbols in this group occur frequently in Tibetan textiles and decorative arts but do not have the potent meaning in Tibet that they did in their native China. Tibetans admire the beauty of these elements and have knowledge of their general auspicious nature.

Bat (happiness)
Shou (long life)
Mountain/sea (earth)
Clouds (sky)
Peony (spring, good fortune)
Chrysanthemum (autumn, joviality)
The three fruits: peach, pomegranate, citron
(immortality, fertility, happiness)

SELECTED BIBLIOGRAPHY
*Recommended General Text

I. GEOGRAPHY

Carrasco, Pedro. *Land and Polity in Tibet*. Seattle: University of Washington Press, 1959.

International Commission of Jurists, Legal Inquiry Committee on Tibet, *Tibet and the Chinese People's Republic*, Geneva, 1960.

Karan, Pradyumna. *The Changing Face of Tibet; the Impact of Chinese Communist Ideology on the Landscape*. Lexington: The University Press of Kentucky, 1976.

Michael, Franz. *Rule by Incarnation*. Boulder: Westview Press, 1982.

Richardson, Hugh E. *A Short History of Tibet*. New York: Dutton, 1962.

Stein, Rolf A. *Tibetan Civilization*. Translated by J. Stapleton Driver. London: Faber and Faber, 1972; *La Civilisation Tibétaine*, revised and enlarged second edition. Paris: Le Sycomore-L'Asiathèque, 1981.

II. HISTORY

Beckwith, Christopher I. "Tibet and the Early Medieval Florissance in Eurasia, a Preliminary Note on the Economic History of the Tibetan Empire." *Central Asiatic Journal*, no. 21 (1977), pp. 89–104.

_____. "The Tibetan Empire in the West." In *Tibetan Studies in Honour of Hugh Richardson*, editors Michael Aris and Aung San Suu Kyi. Warminster, England: Aris and Phillips Ltd., 1981, pp. 30–38.

Blondeau, Anne-Marie. "Le Tibet, Apercu Historique et Geographique." In *Essais sur l'Art du Tibet*. Paris: Maisonneuve, 1977.

_____. "Les Religions du Tibet." In *Histoire des Religions*, vol. III. Paris: Encyclopédie de la Pléiade, 1976.

Goré, F. "Notes sur les Marches Tibétaines du Sseu-tch'ouen et du Yunnan." *Bulletin de l'Ecole Francaise d'Extreme Orient*. Paris: 1923.

Haarh, Erik. *The Yar-lun Dynasty: A Study with Particular Regard to the Contributions by Myths and Legends to the History of Ancient Tibet and the Origin and Nature of Its Kings*. Copenhagen: Gads, 1969.

International Commission of Jurists, Legal Inquiry Committee on Tibet, *Tibet and the Chinese People's Republic*, Geneva, 1960.

Karan, Pradyumna. *The Changing Face of Tibet; the Impact of Chinese Communist Ideology on the Landscape*. Lexington: The University Press of Kentucky, 1976.

Karmay, Heather. *Early Sino-Tibetan Art*. Warminster, England: Aris and Phillips Ltd., 1975.

Kolmaś, Josef. *Geneology of Derge*. Prague: Oriental Institute and Academia, Publishing House of Czechoslovakia Academy of Sciences, 1968.

_____. *Tibet and Imperial China: A Survey of Sino-Tibetan Relations Up to the End of the Manchu Dynasty in 1912*. Canberra: Center of Oriental Studies, Australian National University, 1967.

Macdonald, Ariane. "Une lecture de P. T. [Pelliot Tibétain] 1286, 1287, 1038, 1047 et 1290. Essai sur la formation et l'emploi des mythes politiques dans la religion royale de Sroń bcan sgam po." In *Etudes Tibétaines dédiées à la mémoire de Marcelle Lalou*. Paris: Maisonneuve, 1971.

Pelliot, Paul. *Histoire Ancienne du Tibet*. Paris: Maisonneuve, 1961.

Petech, Luciano. *China and Tibet in the Early 18th Century: History of the Establishment of the Chinese Protectorate in Tibet*. Leiden: E. J. Brill, 1950.

————. *Aristocracy and Government in Tibet (1728–1959)*. Rome: Istituto Italiano per il Medio ed Estremo Orienti, 1973.

*Richardson, Hugh E. *A Short History of Tibet*. New York: Dutton, 1962.

————. "The Rva-sgreng Conspiracy of 1947." In *Tibetan Studies in Honour of Hugh Richardson,* edited by Michael Aris and Aung San Suu Kyi. Warminster, England: Aris and Phillips, Ltd., 1981, pp. XVI–XX.

Shafer, Edward H. *Golden Peaches of Samarkand: A Study of T'ang Exotics*. Berkeley and Los Angeles: University of California Press, 1963.

*Shakabpa, Tsepon W. D. *Tibet, A Political History.* New Haven: Yale University Press, 1967.

*Snellgrove, David, and Richardson, Hugh. *A Cultural History of Tibet.* London: George Weidenfeld and Nicolson, Ltd. 1968.

Sperling, Elliot. "A Captivity in Ninth Century Tibet." *The Tibet Journal,* vol. IV, no. 4 (1979).

Stein, Rolf A. *Tibetan Civilization*. Translated by J. Stapleton Driver. London: Faber and Faber, 1972; *La Civilisation Tibétaine,* revised and enlarged second edition. Paris: Le Sycomore-L'Asiathèque, 1981.

Teichman, Eric. *Travels of a Consular Officer in Eastern Tibet*. Cambridge: University Press, 1922.

*Tucci, Giuseppe. *Tibetan Painted Scrolls*. 2 vols. Rome: Libreria dello Stato, 1949.

————. *Indo-Tibetica*, vols. I–IV. Rome: Reale Accademia d'Italia, 1935–41.

————. "The Wives of Srong btsan sgam po," *Oriens Extremis,* IX. Wiesbaden: O. Harrassowitz, 1962.

III. RELIGION

*Blondeau, Anne-Marie. "Les Religions du Tibet." In *Histoire des Religions,* vol. III. Paris: Encyclopédie de la Pléiade, 1976.

Conze, Edward. *Buddhism: Its Essence and Development*. Oxford: Bruno Cassirer, 1951; New York: Harper, 1959.

*Dalai Lama, Fourteenth. *The Buddhism of Tibet and the Key to the Middle Way.* Wisdom of Tibet Series, no. 1. Translated by Jeffrey Hopkins and Lati Rinpoche. New York: Harper and Row, 1975.

Karmay, Samten. "A General Introduction to the History and Doctrines of Bon." *Memoirs of the Research Department of the Toyo Bunko,* no. 33. Tokyo, 1975.

Lhalungpa, Lobsang. "The Religious Culture of Tibet." *The Tibet Journal,* vol. I, nos. 3 and 4 (1976), pp. 9–16.

Macdonald, Ariane. "Une lecture de P. T. [Pelliot Tibétain] 1286, 1287, 1038, 1047 et 1290. Essai sur la formation et l'emploi des mythes politiques dans la religion royale de Sroń bcan sgam po." In *Etudes Tibétaines dédiées à la mémoire de Marcelle Lalou*. Paris: Maisonneuve, 1971.

———— and Imaeda, Yoshiro. *Choix de documents tibétains conservés à la Bibliothèque Nationale, complété par quelques manuscrits de l'India Office et du British Museum*, vols. I and II. Paris: Bibliothèque Nationale, 1978 and 1979.

Rahula, Walpola. *What the Buddha Taught*. New York: Grove Press, 1974.

*Snellgrove, David. *Buddhist Himalaya*. Oxford: Bruno Cassirer, 1957.

*Stein, Rolf A. *Tibetan Civilization*. Translated by J. Stapleton Driver. London: Faber and Faber, 1972; *La Civilisation Tibétaine*, revised and enlarged second edition. Paris: Le Sycomore-L'Asiathèque, 1981.

*Tucci, Giuseppe. *The Religions of Tibet*. Translated by Geoffrey Samuels. Berkeley: University of California Press, 1980.

IV. SOCIETY

Carrasco, Pedro. *Land and Polity in Tibet*. Seattle: University of Washington Press, 1959.

*Dalai Lama, Fourteenth. *My Land and My People*. New York: McGraw-Hill, 1962.

Khyongla, Rato. *My Life and Lives*. New York: Dutton, 1977.

*Michael, Franz. *Rule by Incarnation*. Boulder: Westview Press, 1982.

*Norbu, Thubten Jigme, and Turnbull, Colin M. *Tibet: An Account of the History, the Religion, and the People of Tibet*. New York: Simon and Schuster, 1969.

Taring, Rinchen Dolma. *Daughter of Tibet*. London: Camelot Press, 1970.

*Tucci, Giuseppe. *Tibet Land of Snows*. Translated by J. Stapleton Driver. London: Elek Books, 1967.

V. ARCHITECTURE

Henss, Michael. *Tibet, Die Kulturdenkmäler*. Zurich: Atlantis Verlag, 1981.

Snellgrove, David, and Richardson, Hugh. *A Cultural History of Tibet*. London: George Weidenfeld and Nicolson Ltd., 1968.

VI. THE NEWARK MUSEUM COLLECTION

Connolly, Louise. *Tibet: The Country, Climate, People, Customs, Religion and Resources*. Newark: The Newark Museum Association, 1921.

Cutting, C. Suydam. *The Fire Ox and Other Years*. New York: Charles Scribner's Sons, 1947.

Ekvall, Robert B. *Cultural Relations on the Kansu-Tibetan Border*. Publications in Anthropology, occasional paper no. 1. Chicago: University of Chicago Press, 1939.

Kidd, Walter J. *What Made Tibet Mysterious*. Newark Sunday *Call*, October 23, 1921. Reprint. Newark: The Newark Museum Association, 1921–22.

Li An-che. "A Lamasery in Outline." West China Border Research Society *Journal*, XIV, Series A, 1942.

Lipton, Barbara, and Reynolds, Valrae. *The Western Experience in Tibet*. The Museum-New Series, vol. 24, nos. 2 & 3. Newark: The Newark Museum, 1972.

Newark Museum Association. *The Tibet Collection: Edward N. Crane Memorial*, 1912.

_____. *Catalog of Tibetan Objects*, 1921–22.

Olson, Eleanor. *The Tibetan Collection*. The Museum-New Series, vol. 1, no. 2. Newark: The Newark Museum, 1949.

_____. *Catalogue of the Tibetan Collections and Other Lamaist Articles in the Newark Museum*. 5 vols. Newark: The Newark Museum, 1950–71.

_____. *A Tibetan Buddhist Altar*. The Museum-New Series, vol. 16, nos. 1 & 2. Newark: The Newark Museum, 1964.

Reynolds, Valrae. *Tibet: A Lost World*. New York: The American Federation of Arts, 1978.

_____. *A Tibetan Buddhist Altar*. The Museum-New Series, vol. 24, no. 4. Newark: The Newark Museum, 1972.

_____. "The Tibet Archive at The Newark Museum." *Tibet News Review*, Oxon, England, vol. 2, nos. 1 & 2 (1981).

Shelton, Albert L. *Pioneering in Tibet*. New York: Fleming H. Revell Co., 1921.

Shelton, Flora B. *Sunshine and Shadow*. Cincinnati: Foreign Christian Missionary Society, 1912.

_____. *Shelton of Tibet*. New York: George H. Doran Co., 1923.

Teichman, Eric. *Travels of a Consular Officer in Eastern Tibet*. Cambridge: University Press, 1922.

VII. SYMBOLS

Govinda, Lama Anagarika. *Psycho-Cosmic Symbolism of the Buddhist Stupa*. Emeryville: Dharma Publishing, 1976.

*Olshak, Blanche Christine and Wangyal, Geshe Thupten. *Mystic Art of Ancient Tibet*. New York: McGraw-Hill, 1973.

*Snellgrove, David L., ed. *The Image of the Buddha*. Paris: Kodansha International, UNESCO, 1978. .

INDEX OF ILLUSTRATIONS

The illustrations used in this volume are taken from the over two thousand negatives, prints and slides included in a special archival collection at the Newark Museum. The photographs date from 1904 to the present and are drawn primarily from the following sources:

Albert L. Shelton and Roderick A. MacLeod, Kham, 1904–22.
M.G. Griebenow, Amdo, 1922–49
C. Suydam Cutting, southern and central Tibet and border areas, 1930, 1935, 1937.

Photographs of Tibetan refugee areas in the Himalayas (1960–83) and of southern, central and eastern Tibet (1980–81) are from diverse sources. The Newark Museum is grateful to the following individuals for their generosity in adding to the recent photograph archive:

Dr. William D. Carlsen
Dr. Gene Evans
Mr. Michael Henss
Miss Alix Hoch
Mr. and Mrs. Frank Hoch
Mr. Richard Huffman

Mr. James Hurley
Mr. Arthur Leeper
Dr. Wayne Persons
Mr. and Mrs. Lobsang Samden
Mr. and Mrs. Phintso Thonden

Photo Subjects

I. Identified persons:

Batang Lama (#15)
Edward M. Crane (#46)
C. Suydam Cutting (#41, 45)
Mrs. Helen Cutting
(#42, 43, 44, 45)
Dalai Lama, 13th (#6)
Dalai Lama, 14th (#8, 49, 50)
Derge royal family (#25)
Rev. M.G. Griebenow (#39)
Mrs. Horkhang (#44)
Jö Lama (#15, 35, 36)
Alice B. Kendall (#47)
Rev. MacLeod (#38)
Teji (Governor) of Markham
(#37, 38)
Samuel C. Miller (#49)

Eleanor Olson (Frontispiece, #46, 47)
Pangdatshang (#48)
Valrae Reynolds (#49)
Lobsang Sanyes (#43)
Dr. Albert L. Shelton (#35)
Dorothy Shelton (#35, 38)
Dorris Shelton (#35, 38)
Si-lon Yab-shi Lang-dun (#7)
Dumbog Simkhang (#43)
Tsepon Shakabpa (#48)
Depon Surkhang (#48)
Tsephal Taikhang (#47, 48)
Tsarong Dasang Dadul and Mrs. Tsarong (#44)
Dorje Yuthok and Thupchu Yuthok (Frontispiece)

II. Identified places and landmarks:

Batang, Kham (#20, 24, 34)
Chakzam crossing, Tsangpo River, Ü (#23)
Mt. Chomo Lhari, Tsang (#3)
Gyantse (#32)
Kharo-la Pass, Ü (#4)
Labrang, Amdo (#17, 18, 22)
Lhasa (#26, 33)
Litang Border with Itun, Kham (#2)

Mekong (Dza-chu) River, Kham (#1)
Norbu Linga, Lhasa (#31, 43)
Palkhor Choide, Gyantse (#10)
Potala, Lhasa (cover, #13, 14)
Sangen (Badlands), Kham (#28)
Sera Monastery, Lhasa (#16)
Shigatse (#30)
Tashilhunpo, Shigatse (#11, 12)
Yamdrok Tso, Ü (#5)

Work is in progress on the revision and publication of subsequent volumes of the *Catalogue of The Newark Museum Tibetan Collection.*

Volume II: Ritual Objects
Prayer and objects associated with prayer

Altar furnishings

Music and musical instruments

Volume III: Painting and Sculpture
Body positions, gestures, symbols associated with Deities

Wall paintings

Tankas, including painted, appliquéd and embroidered examples

Sculpture, including metal, wood, ivory, lacquer, stone and clay examples

Volume IV: Textiles and Personal Apparel
Flat textiles including rugs, appliqué, imported silks

Costumes and jewelry including ecclesiastic garb, and apparel of the Ü, Tsang, Kham and Amdo areas

Tents

Volume V: Artifacts of Daily Life, Books and Documents
Equipment for food, medicine, travel, herding and farming

Arms and armor

Coins, currency, stamps

Writing, printing, books, documents